COLOR ME GOOD

Coloring Book - Vol. 1

By Matt French

Copyright 2019 by Matt French
All Illustrations are the property of the author

ISBN 9781692591984

All rights reserved. No part of this work may be reproduced or used in any form or by any means—graphic, electronic, or mechanical, including photocopying or information storage and retrieval systems—without written permission from the publisher. The scanning, uploading and distribution of this book, or any part thereof, via the Internet or via any other means without the permission of the publisher is illegal and punishable by law.

Published by **Matt French Art**
1619 Front Street, Lynden, WA 98265
skateboardartstudio@gmail.com

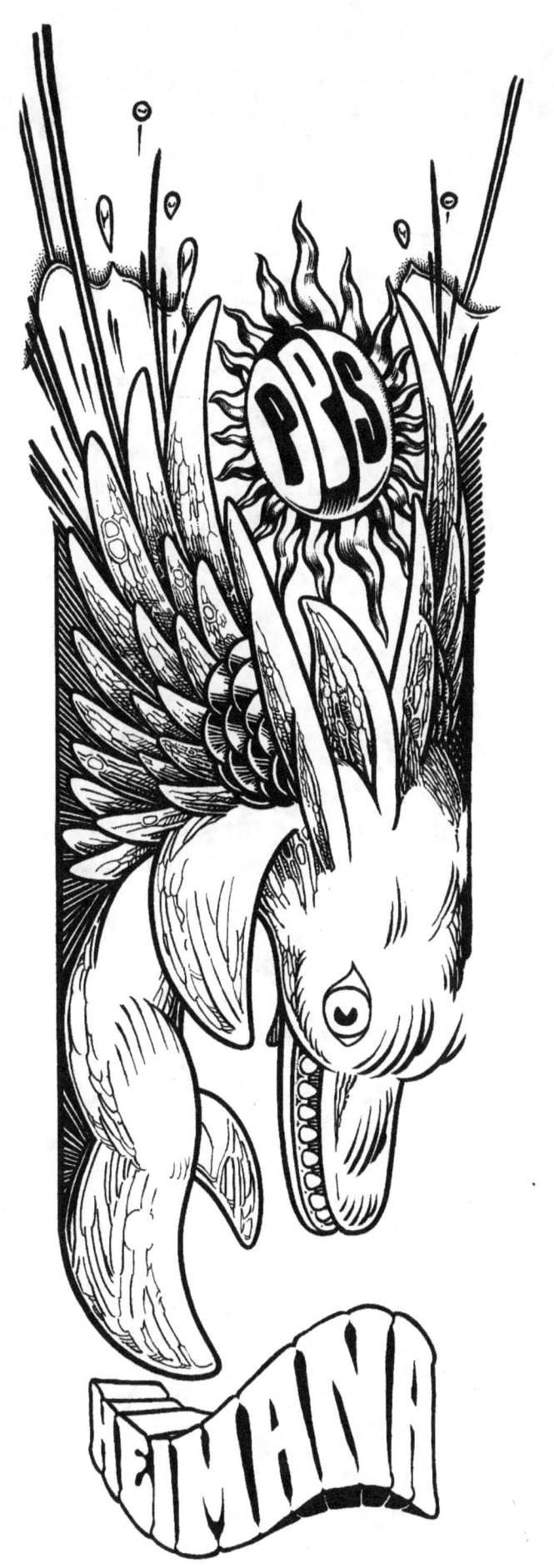

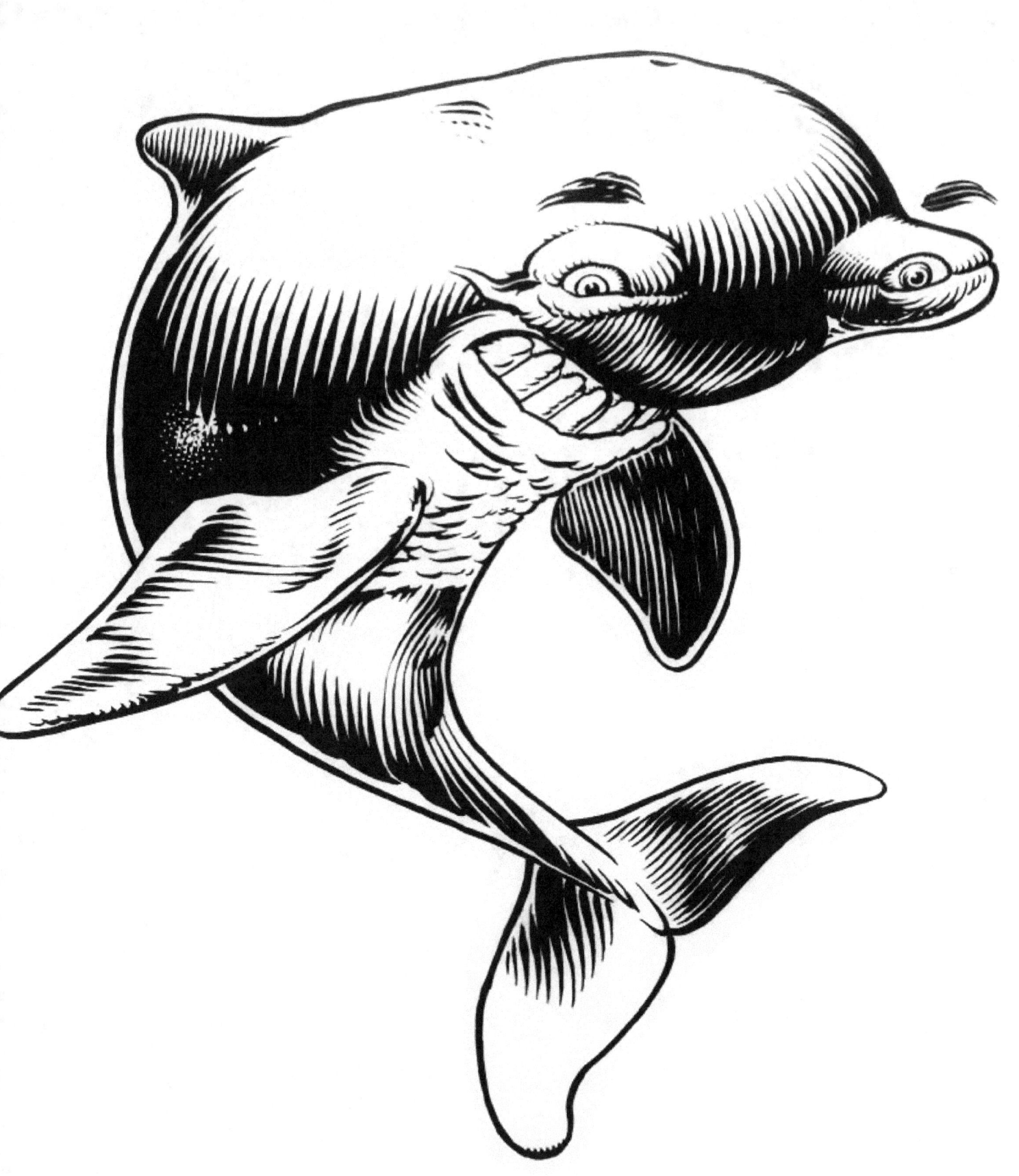

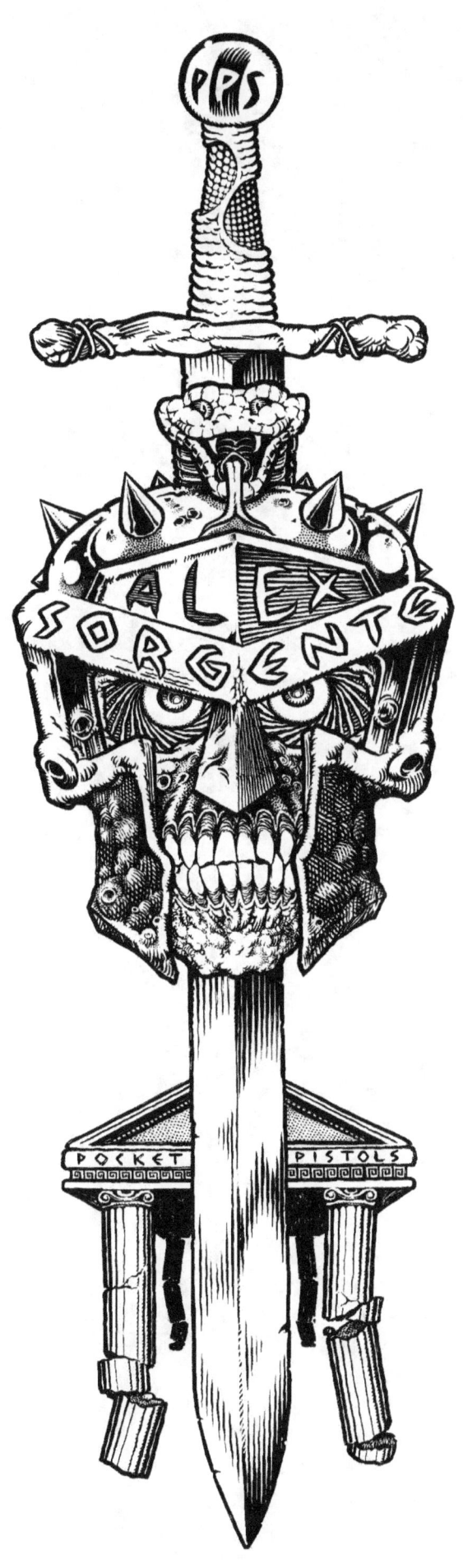

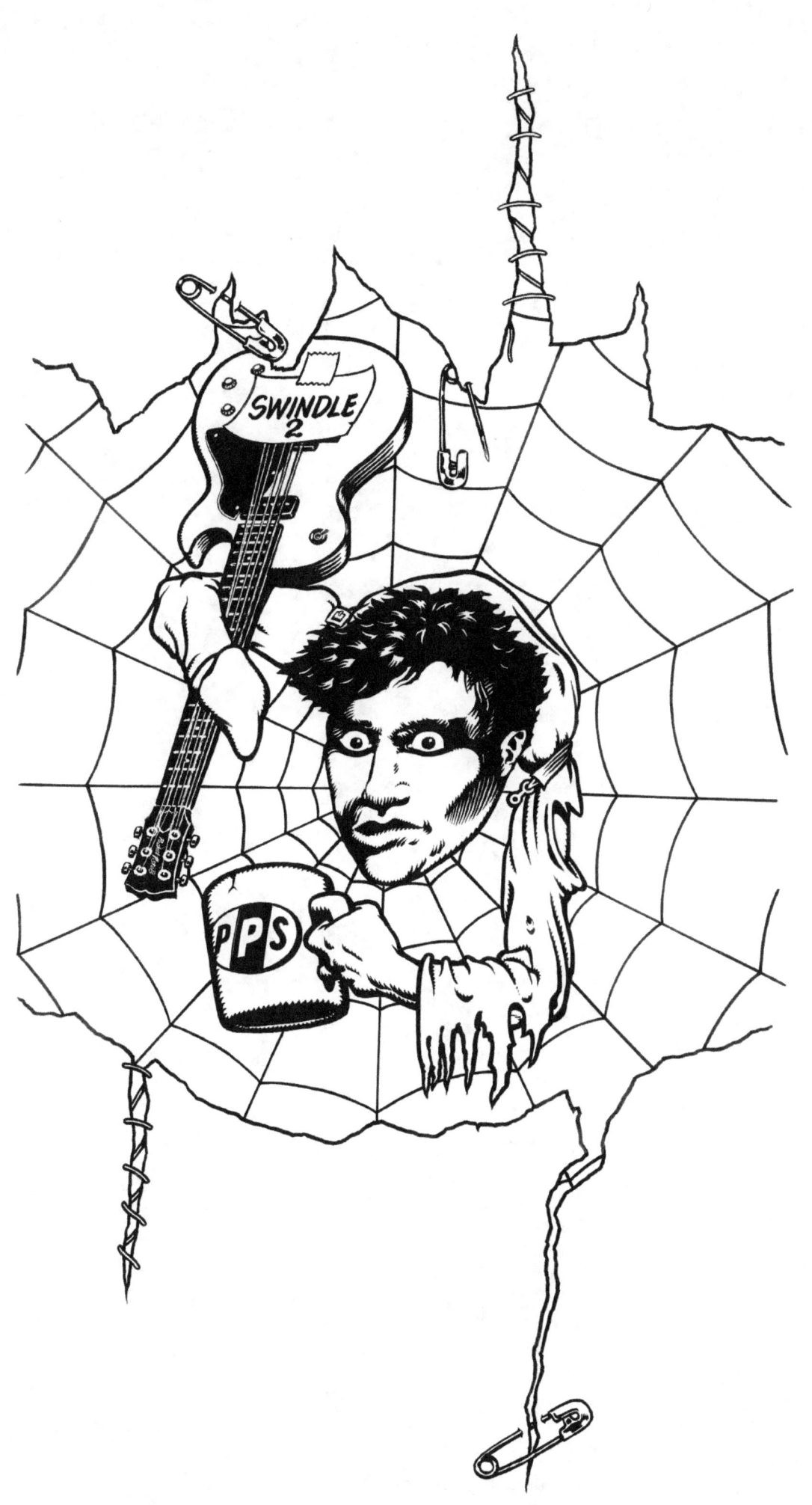

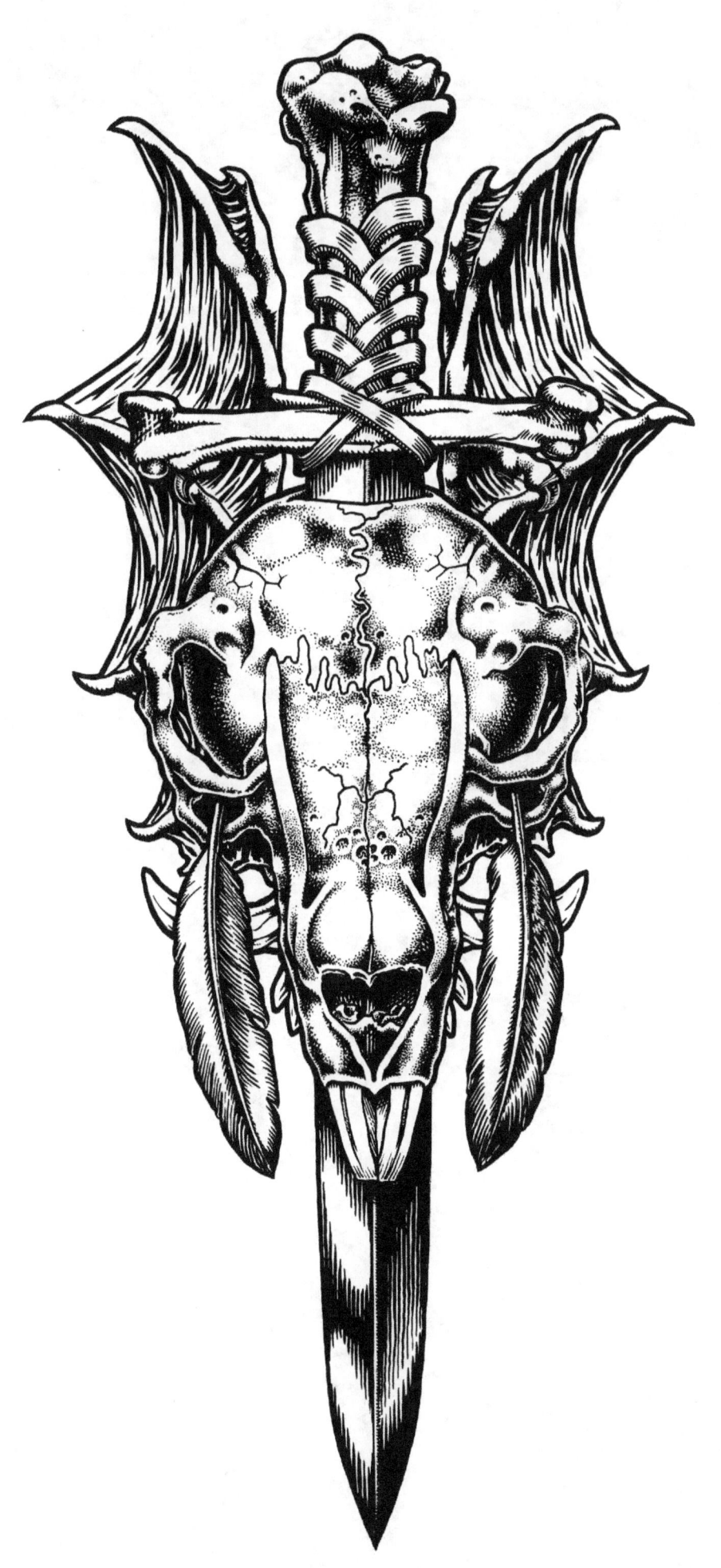

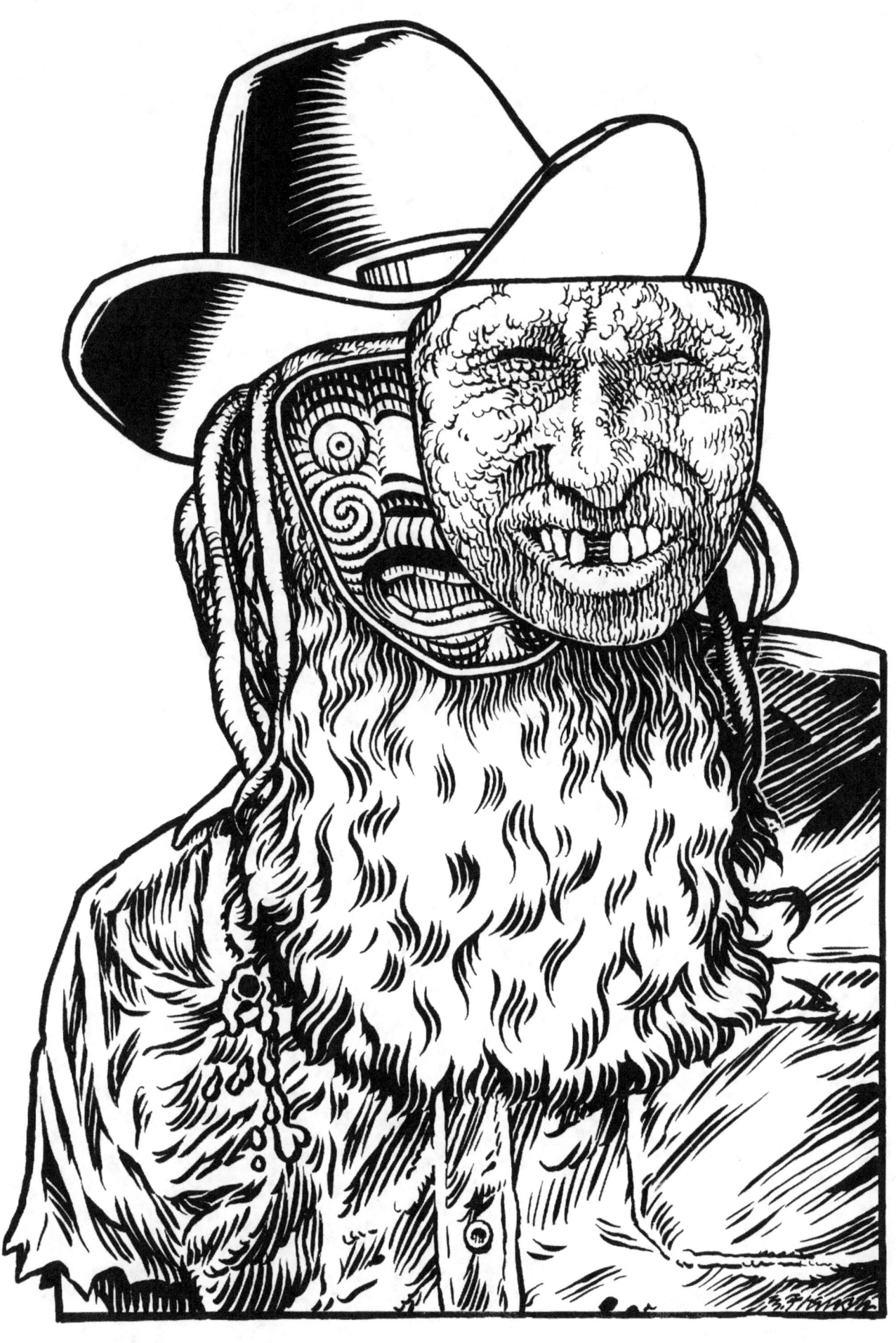

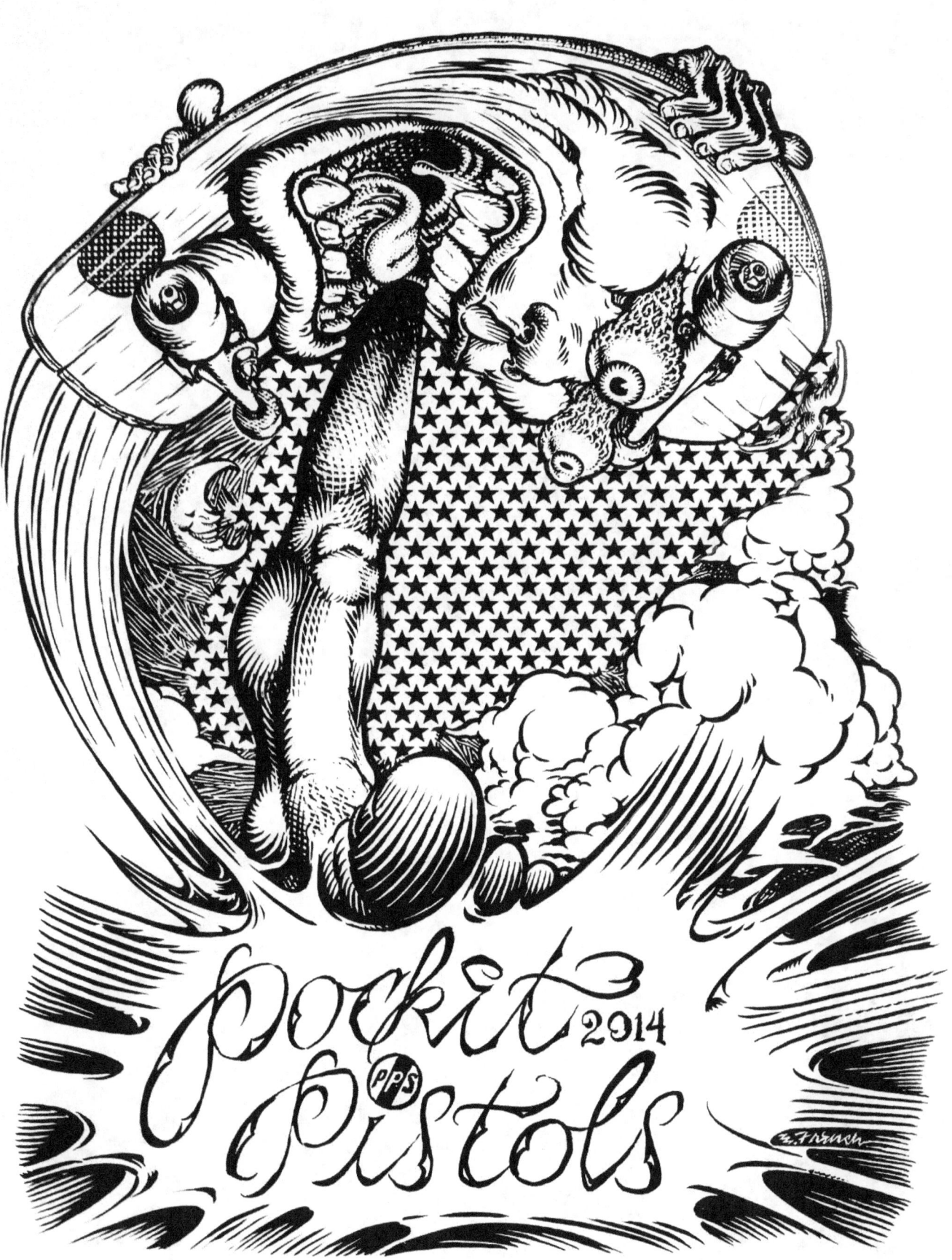

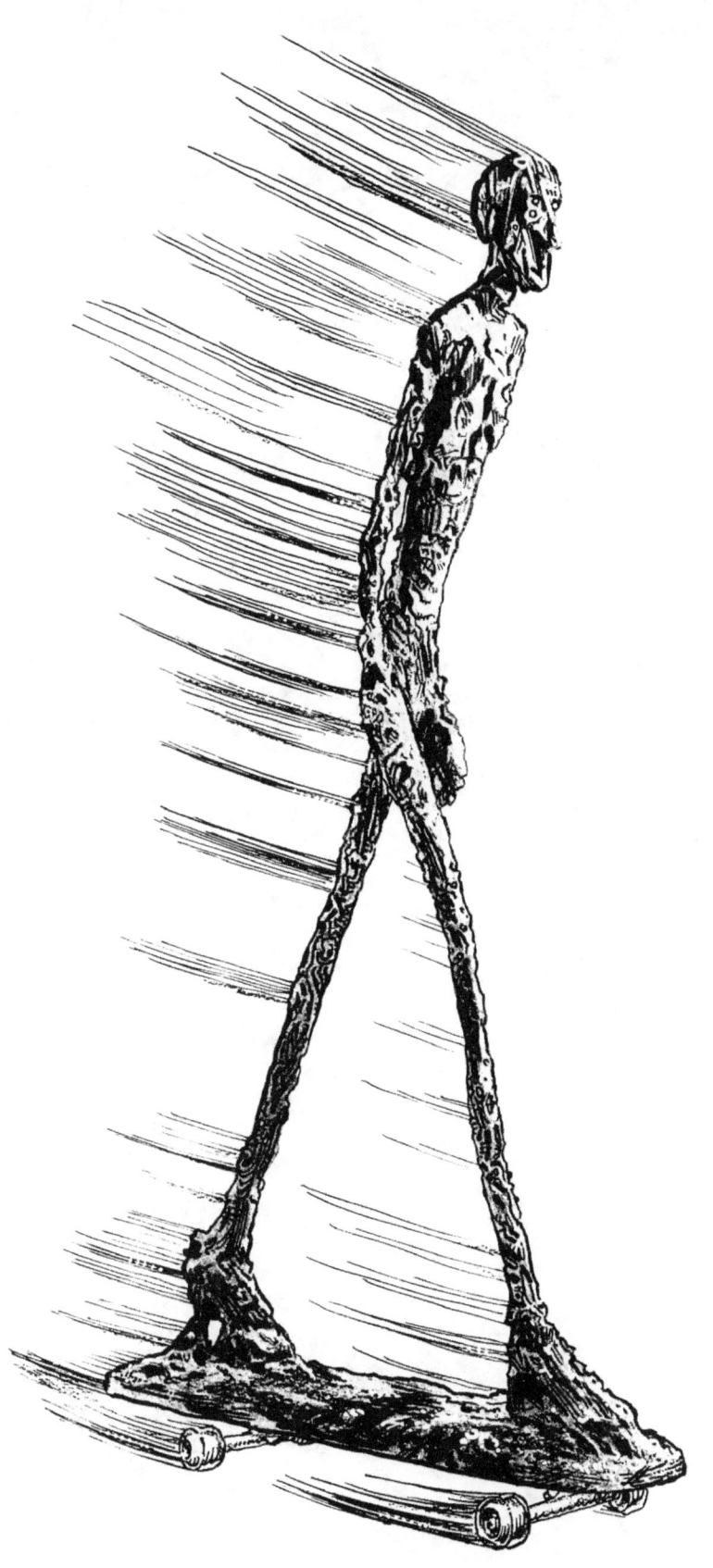

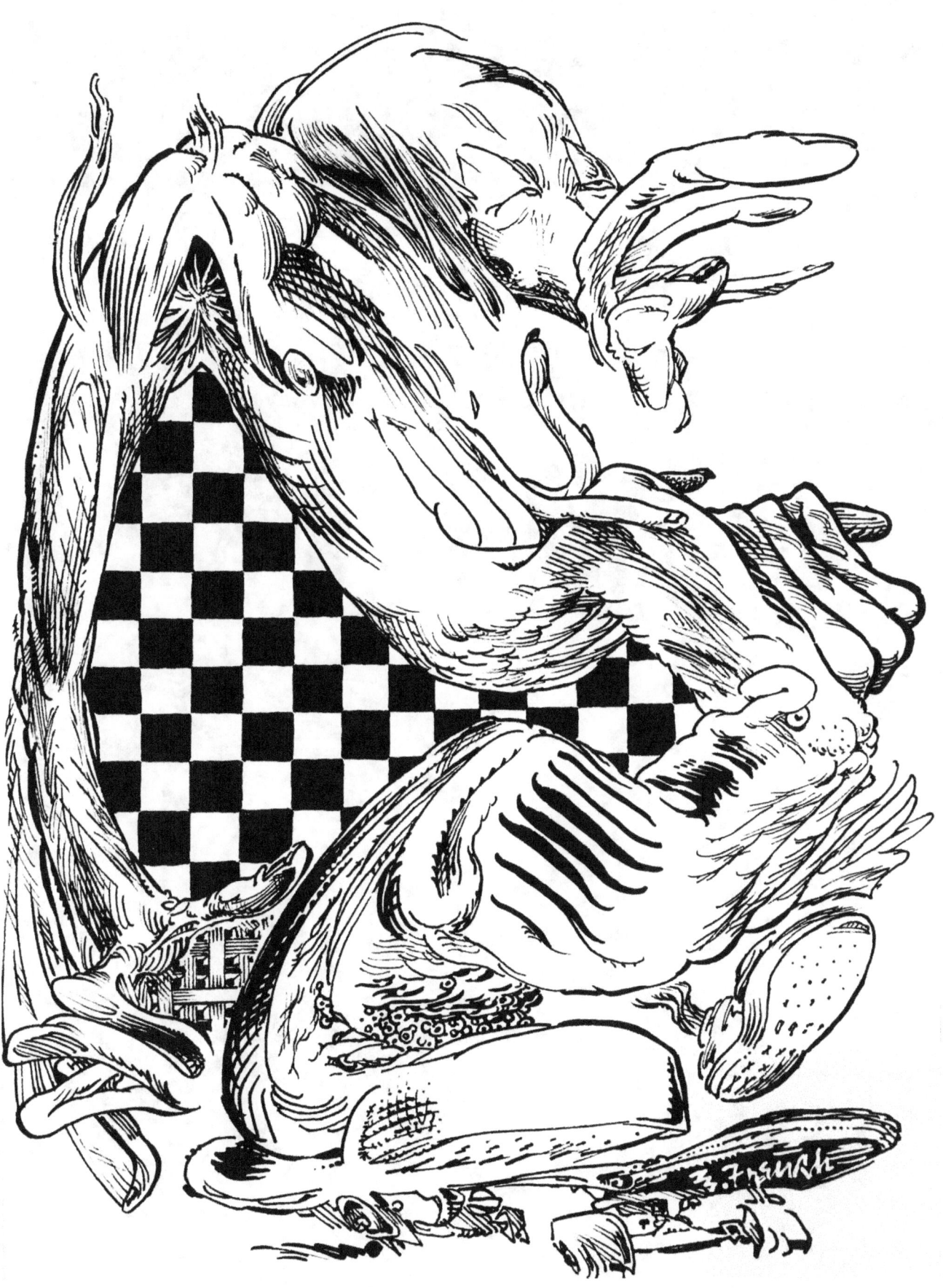

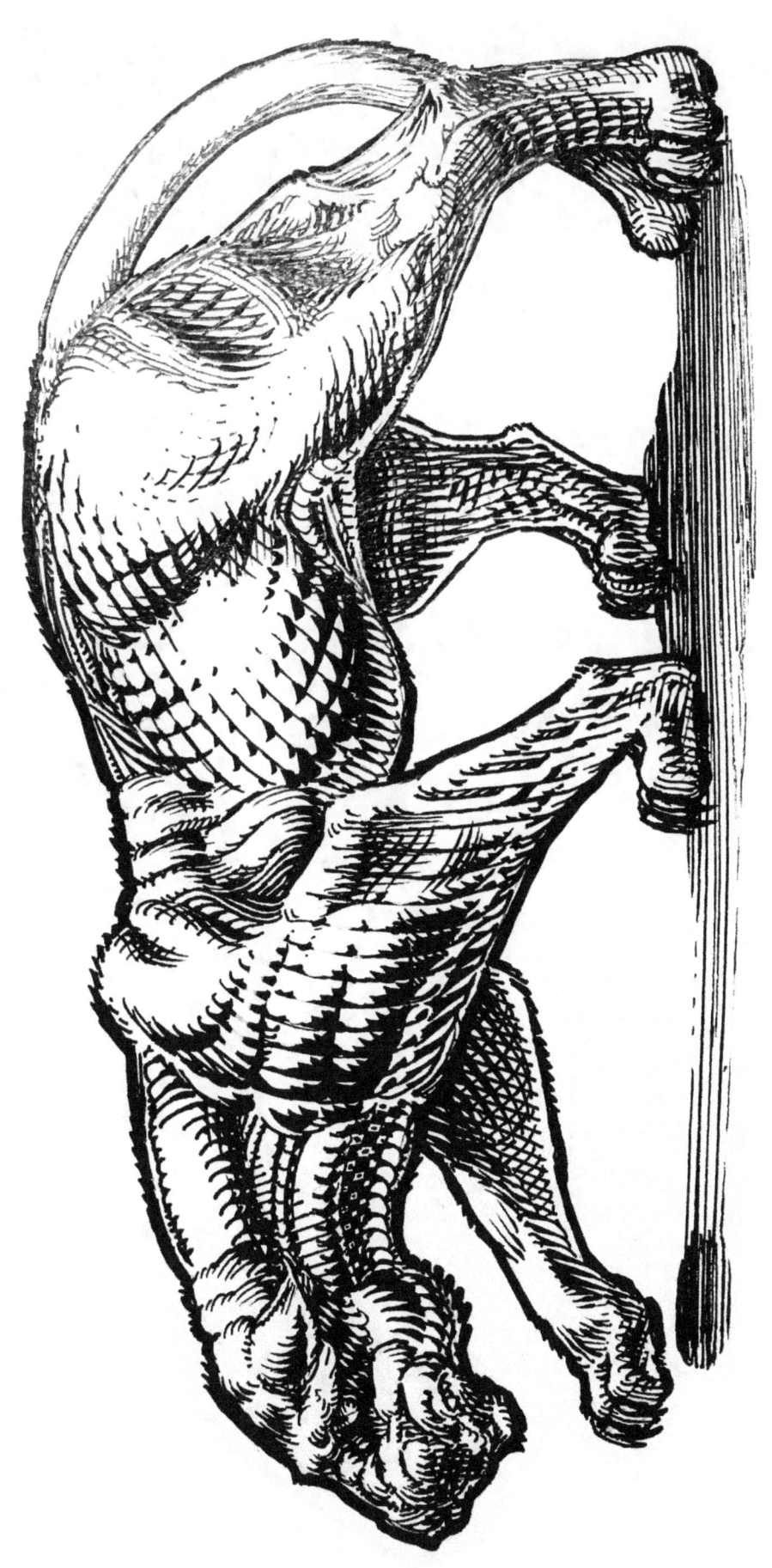

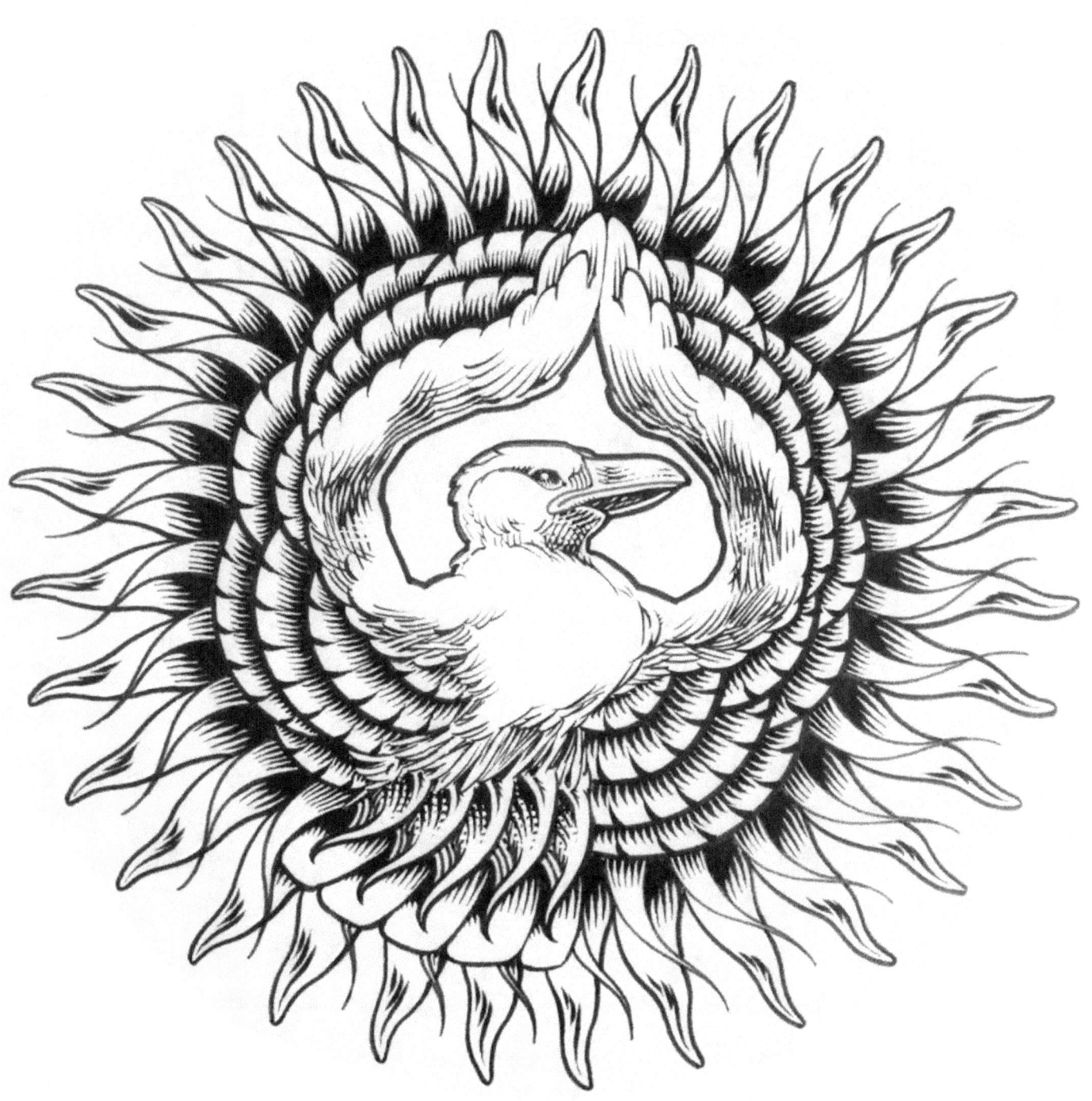

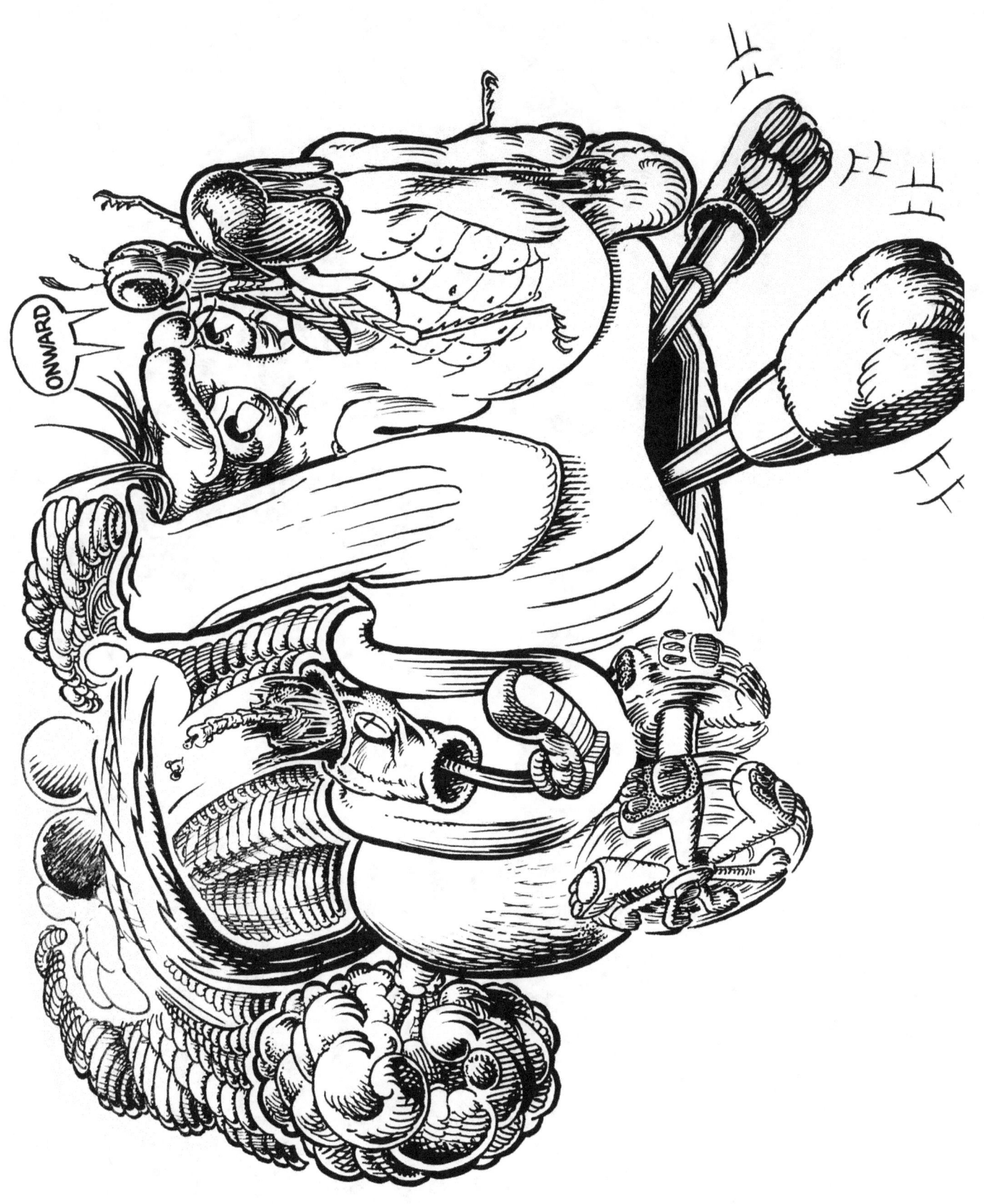

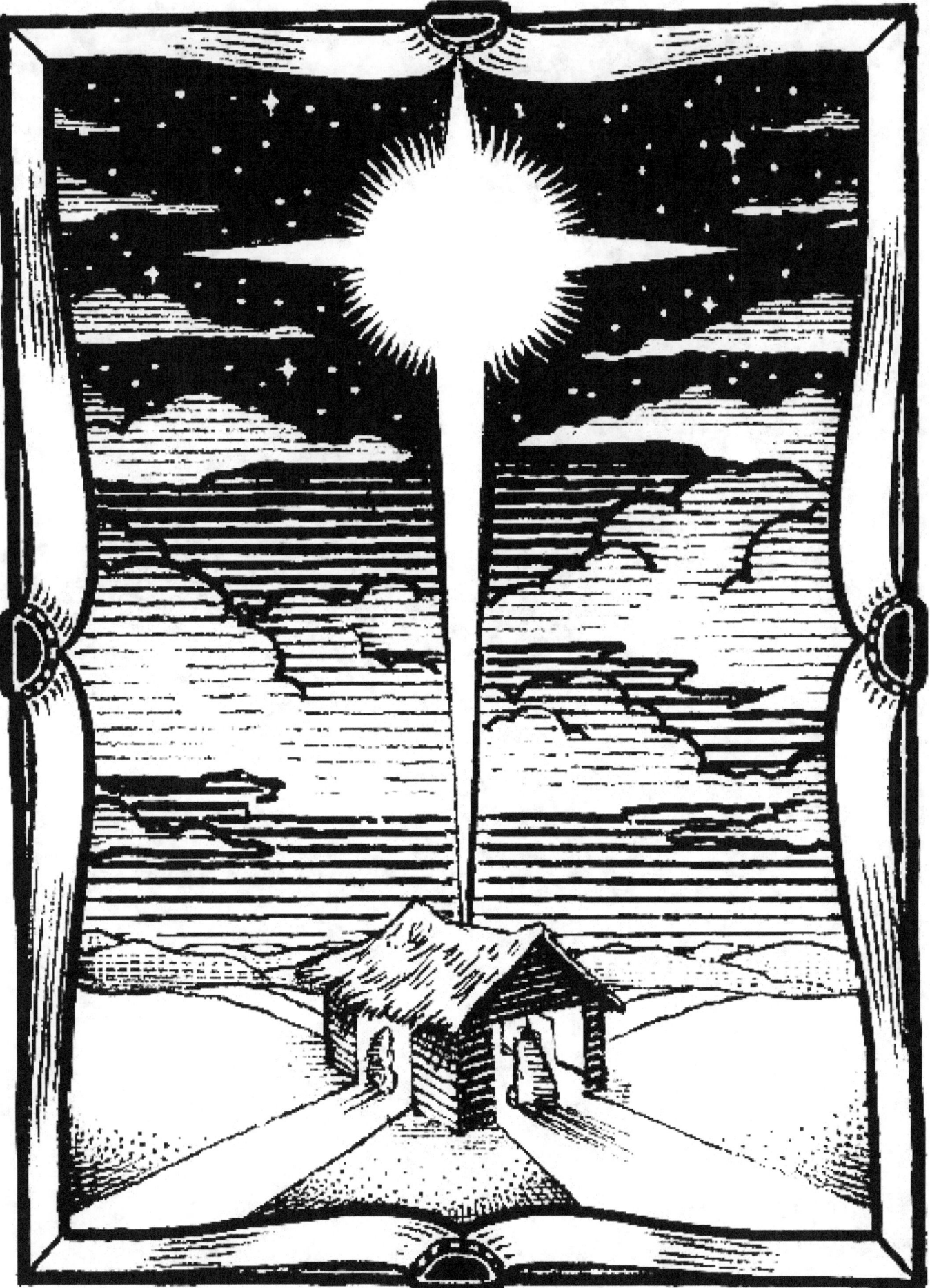

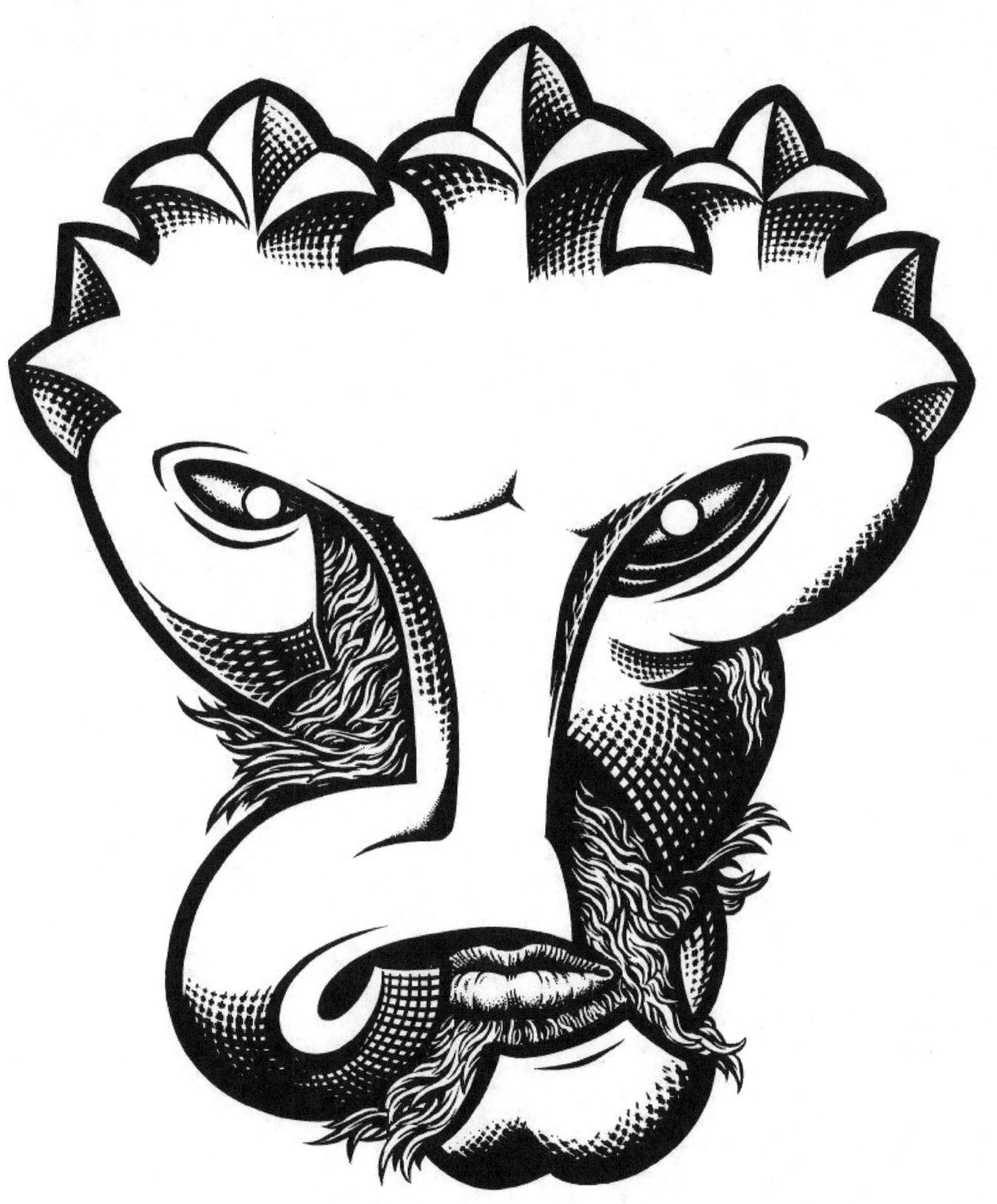

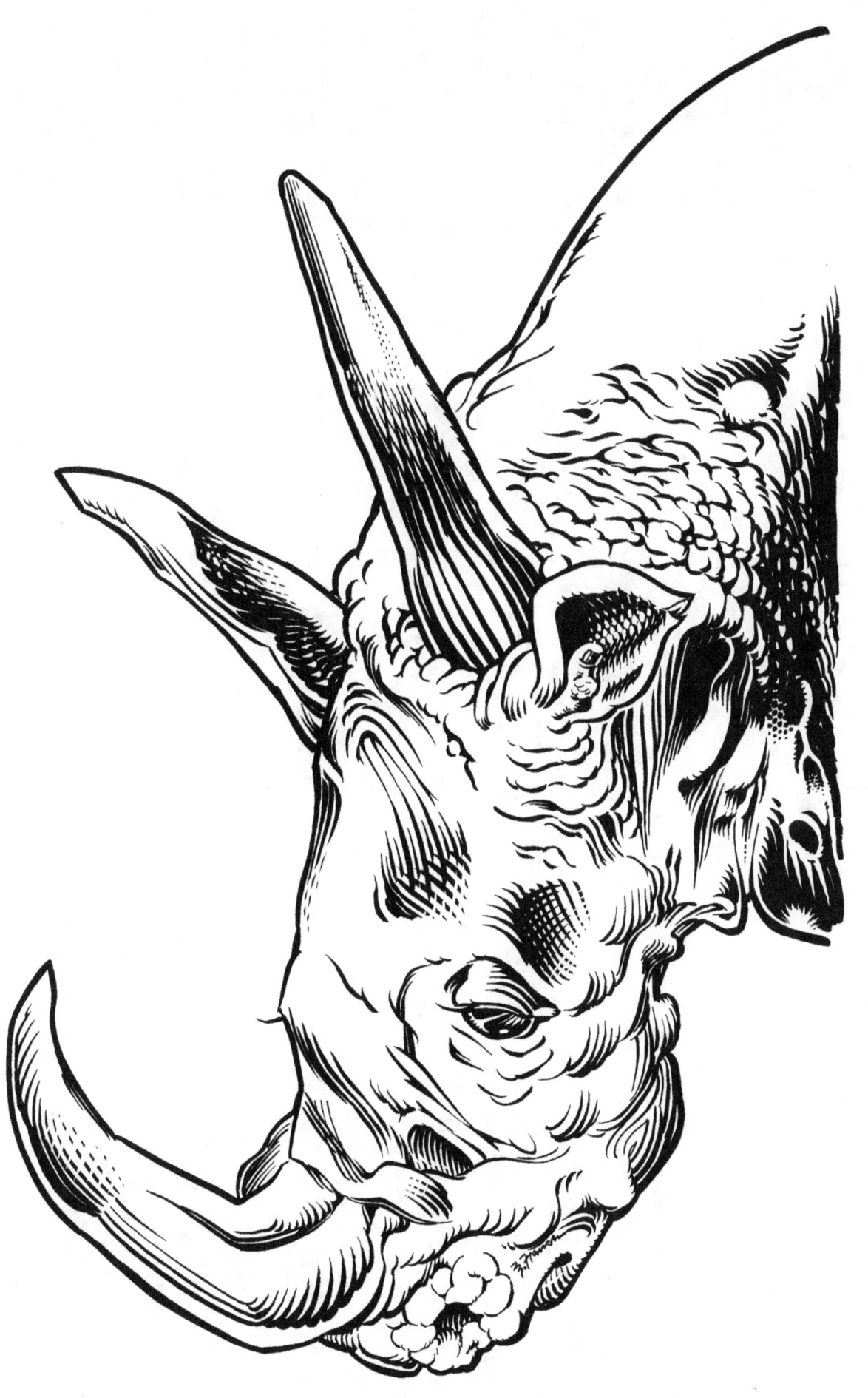

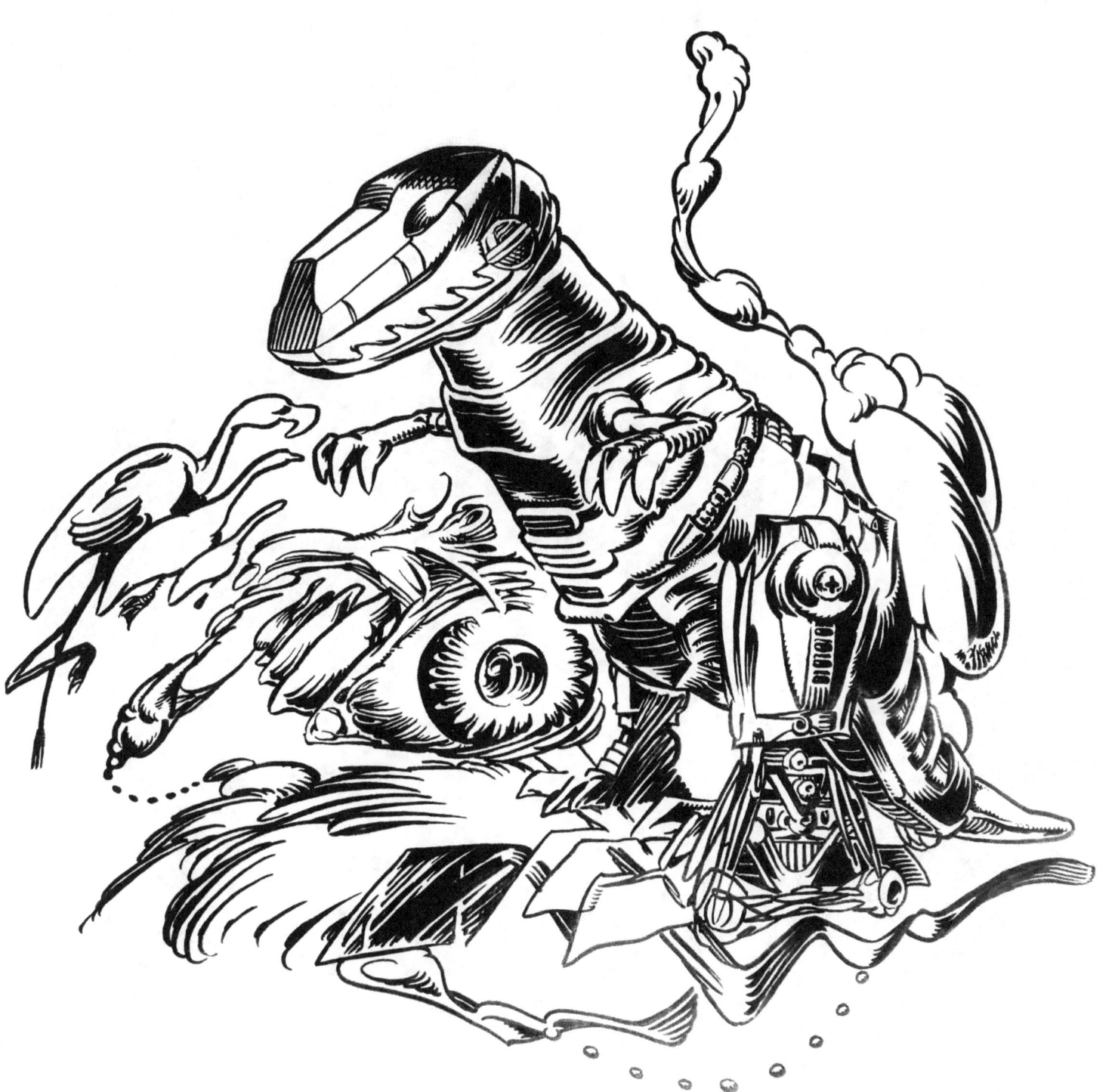

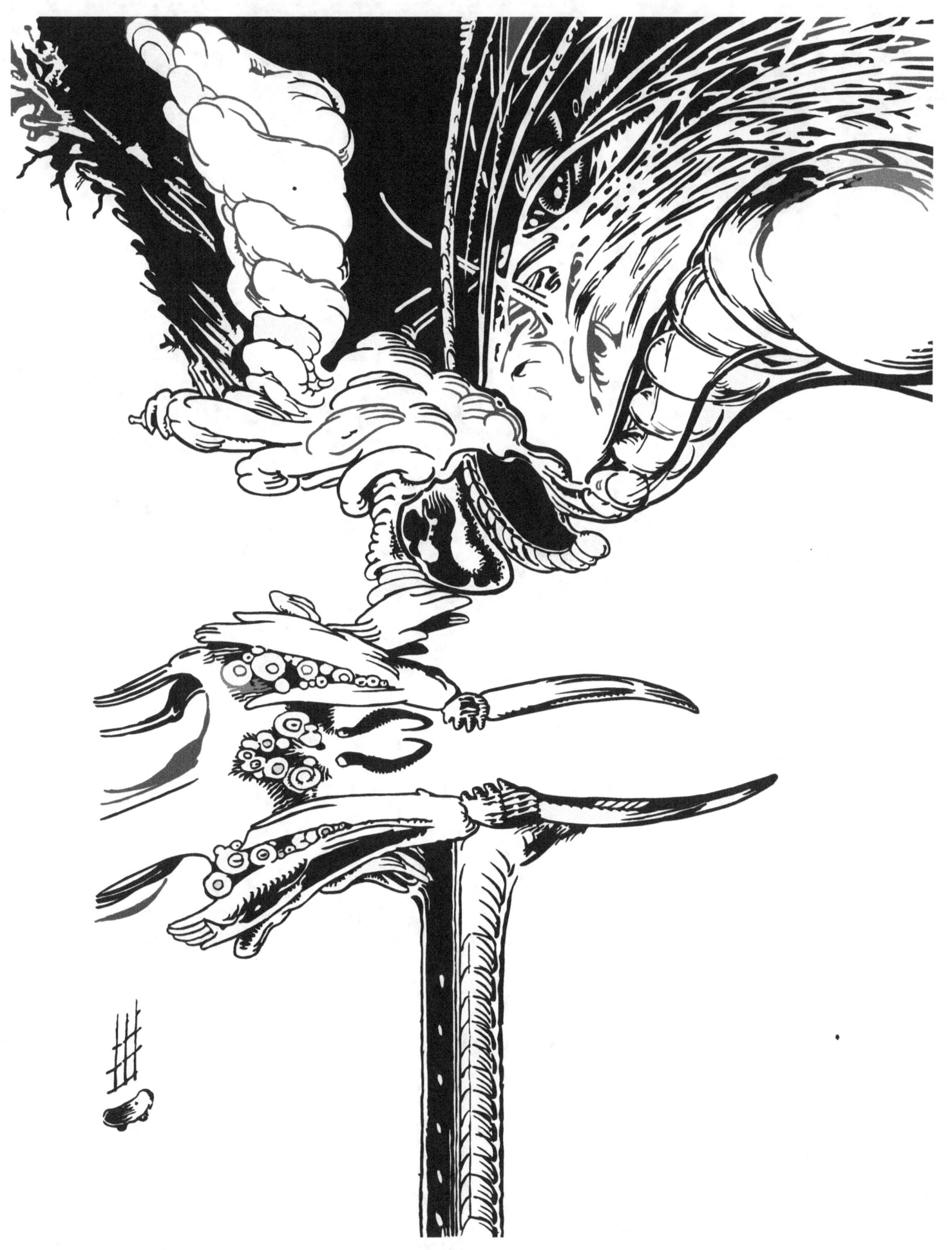

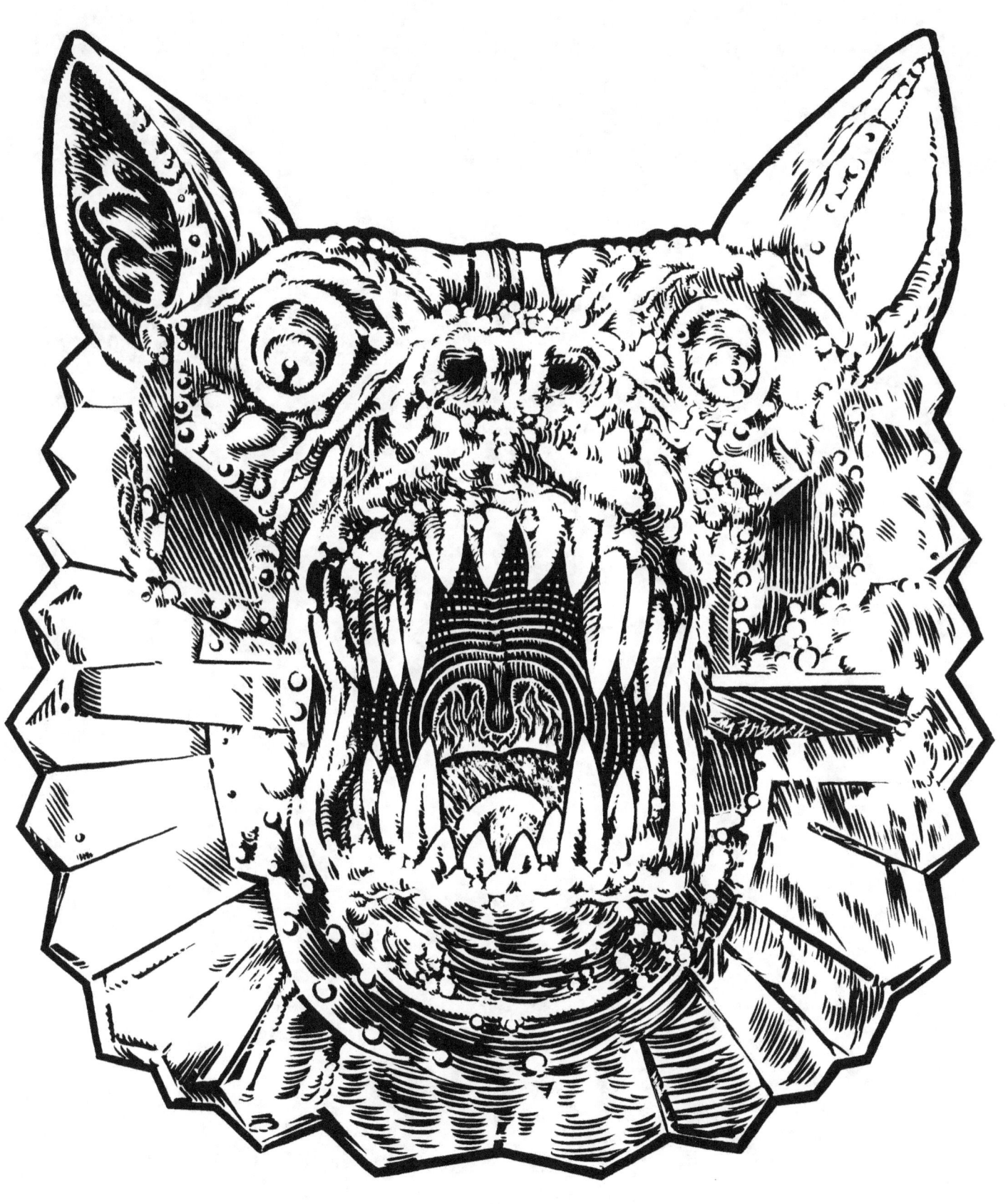

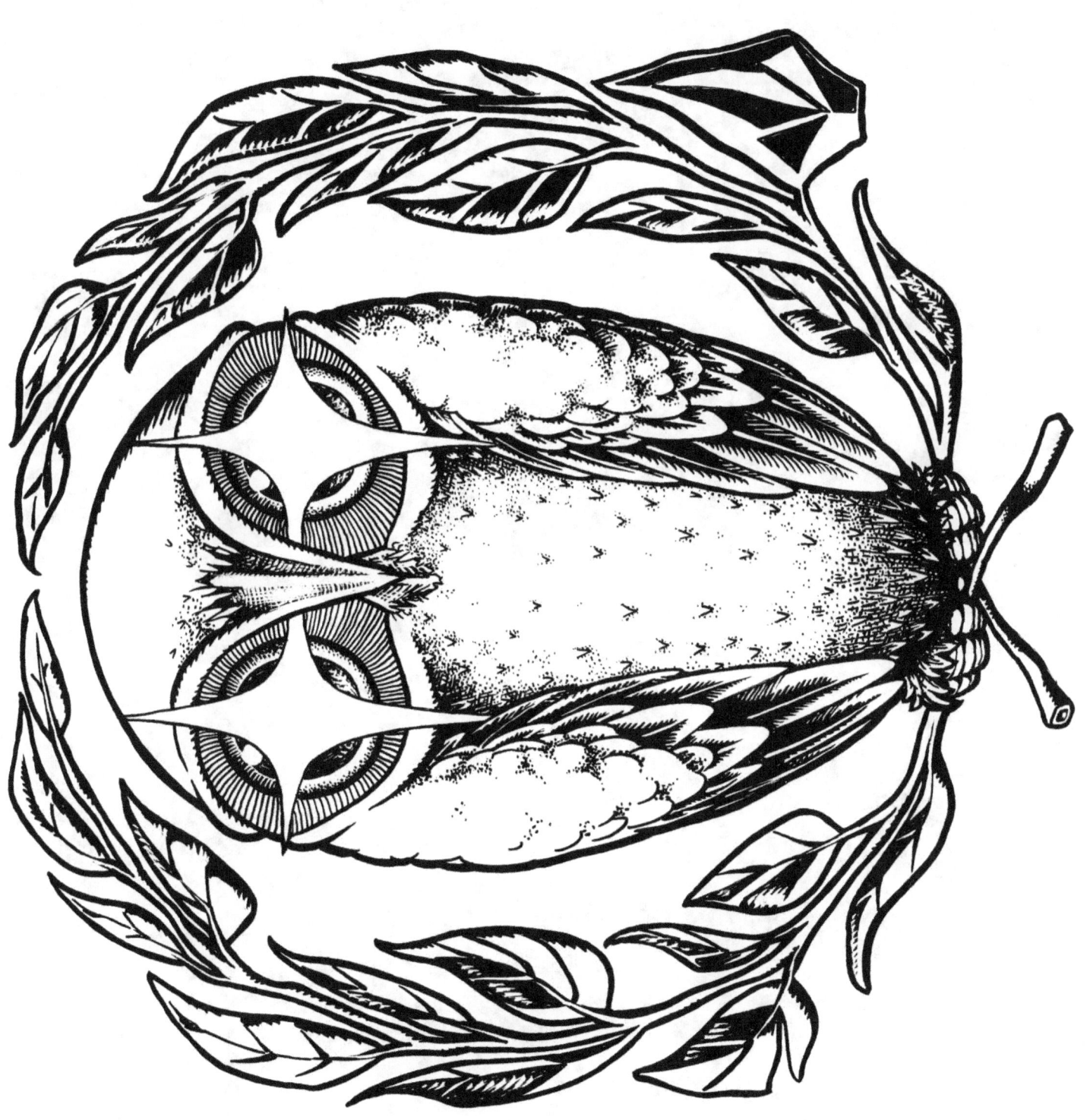

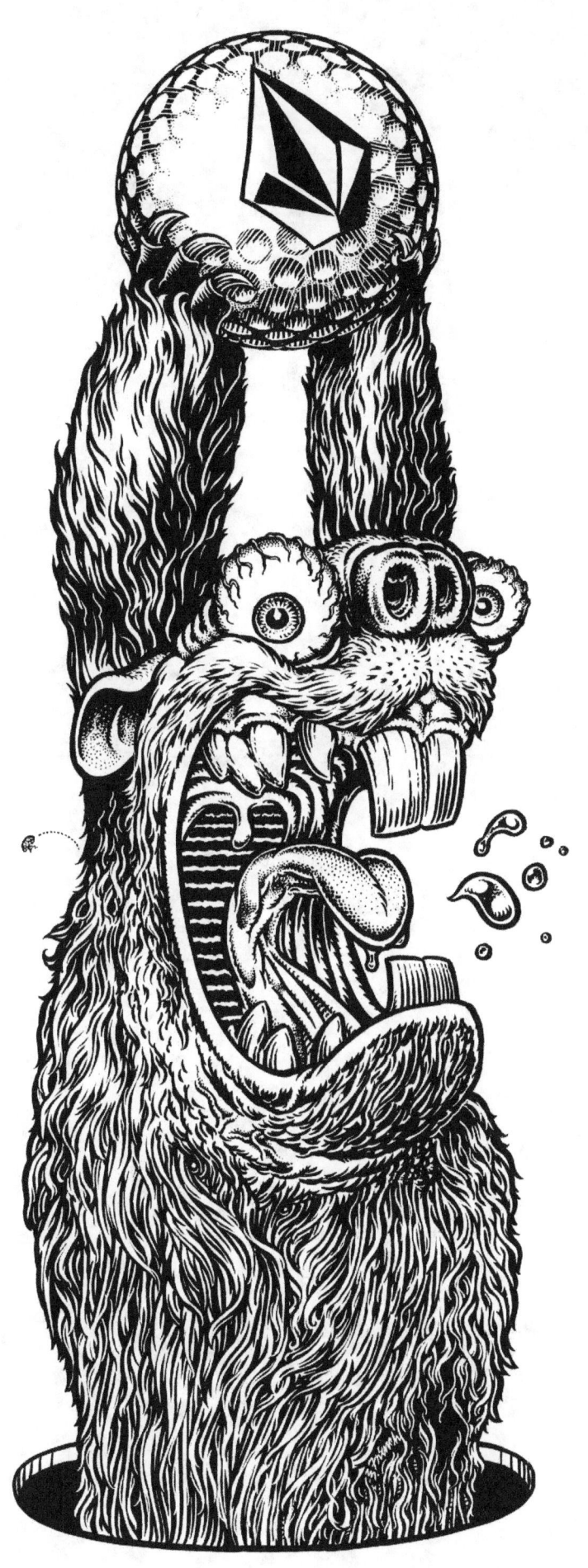

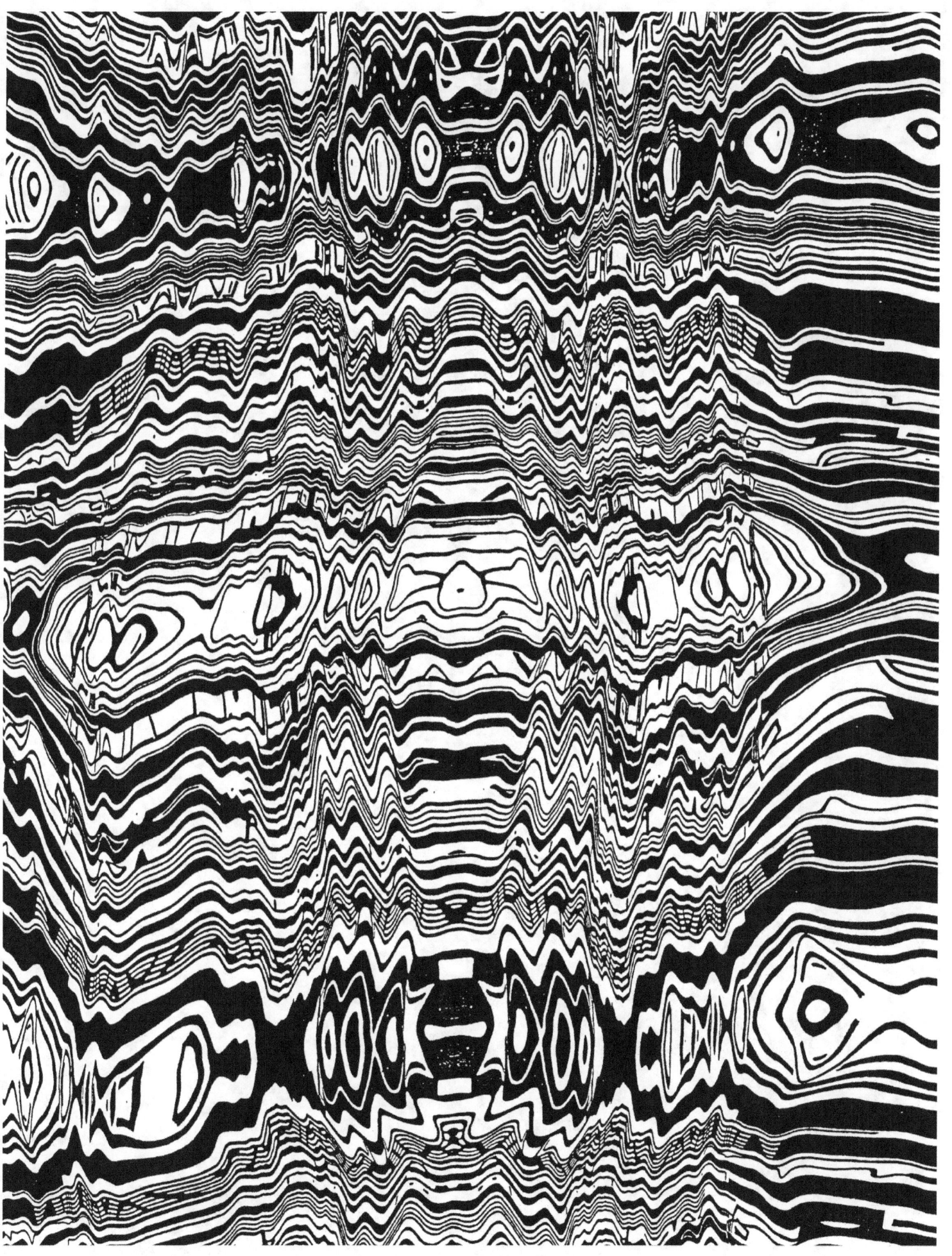

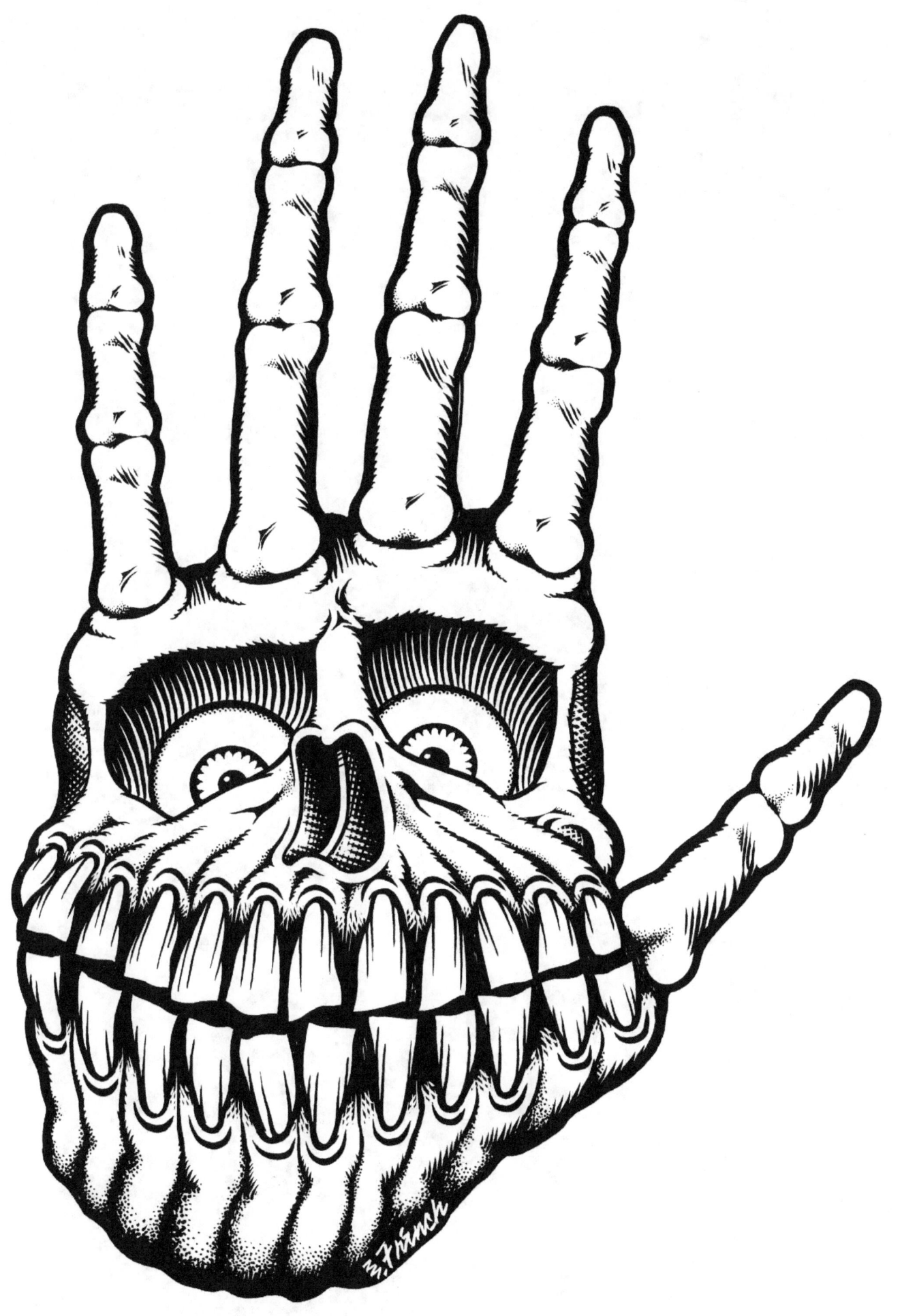

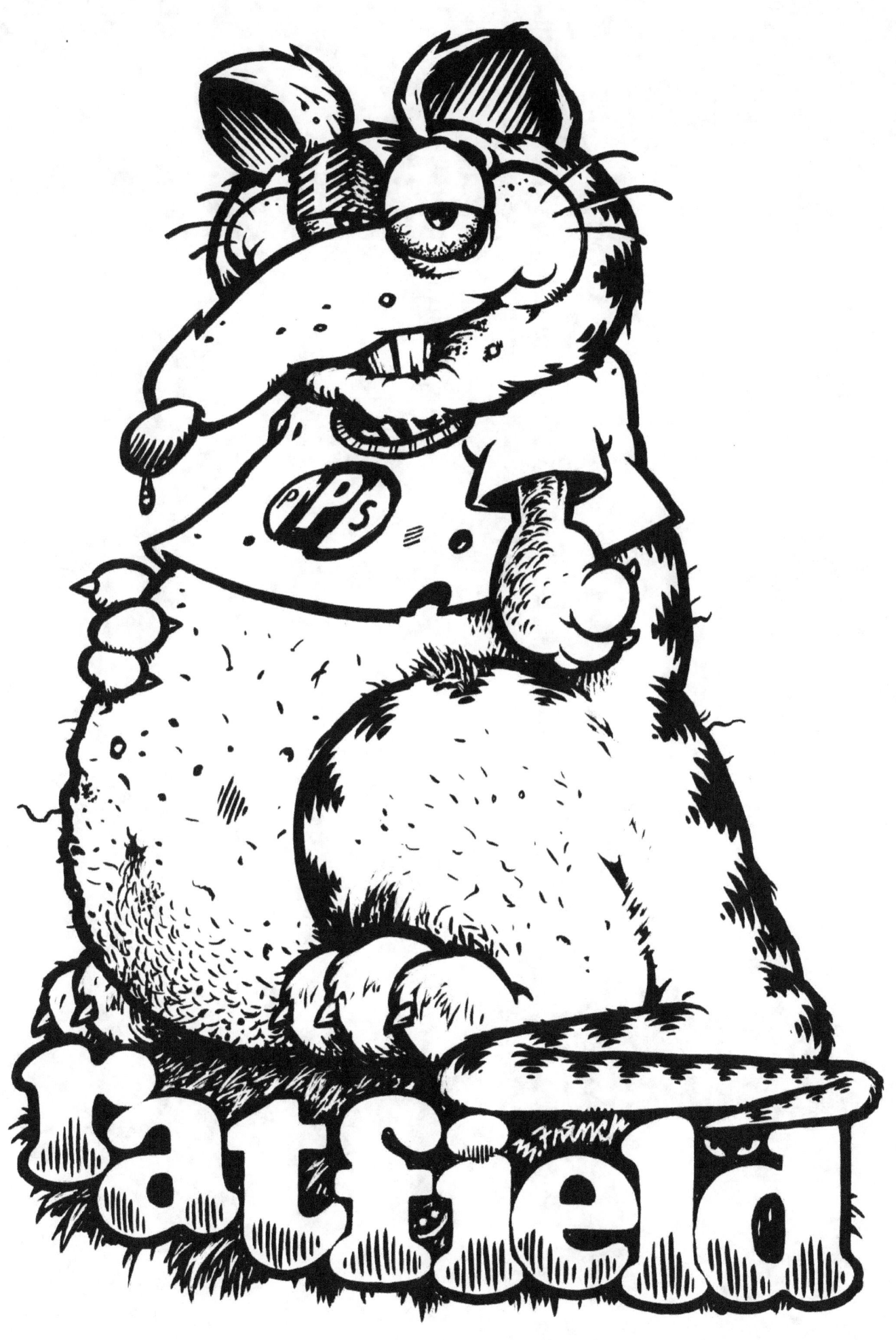

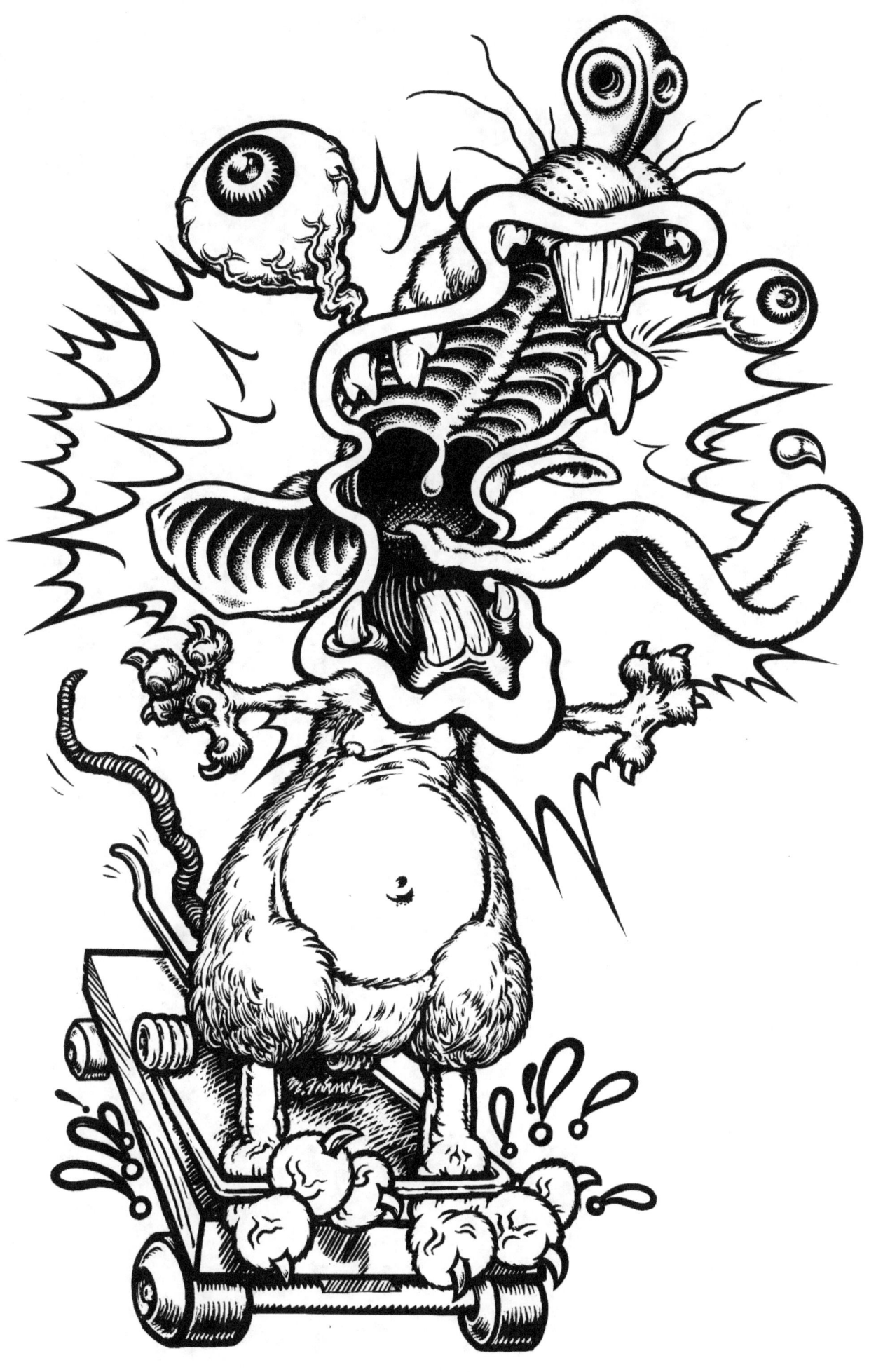

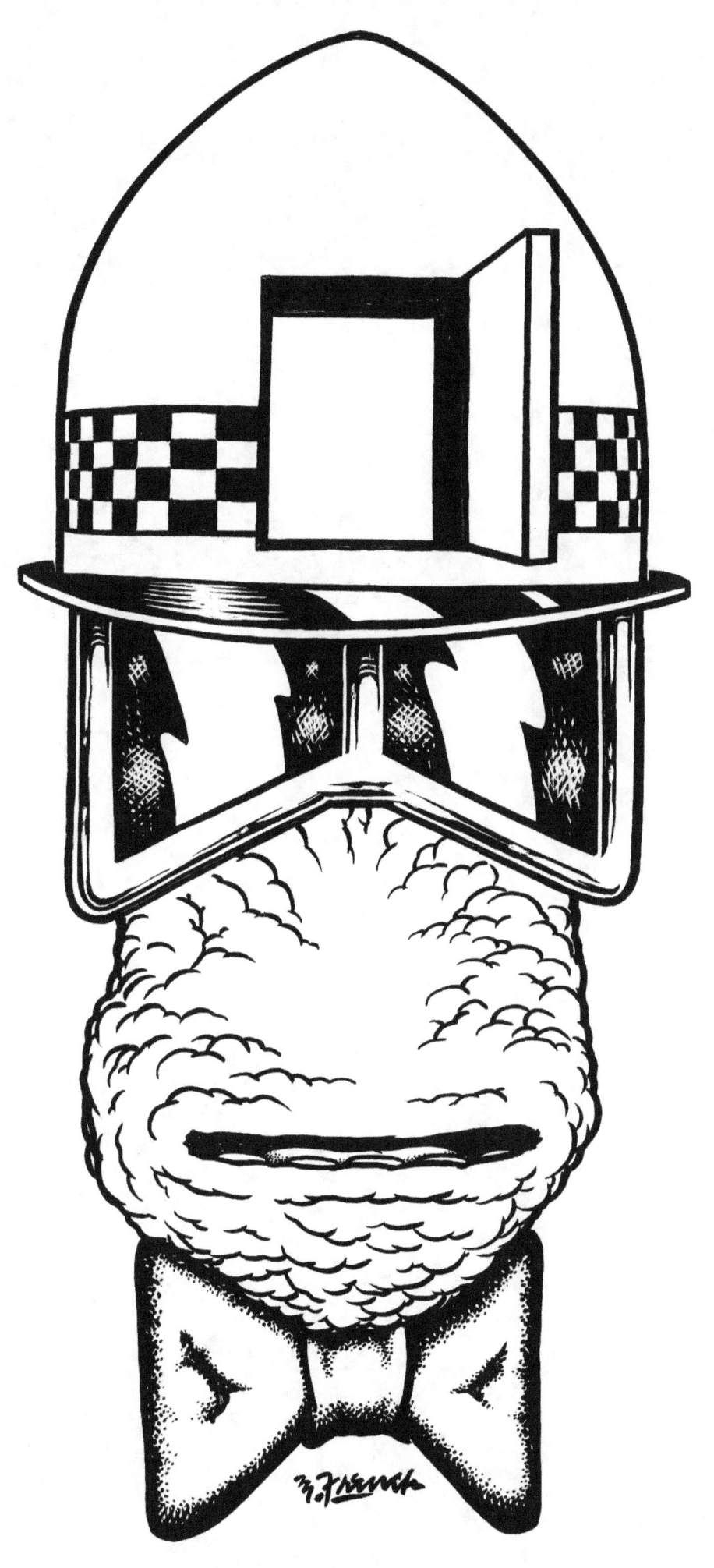

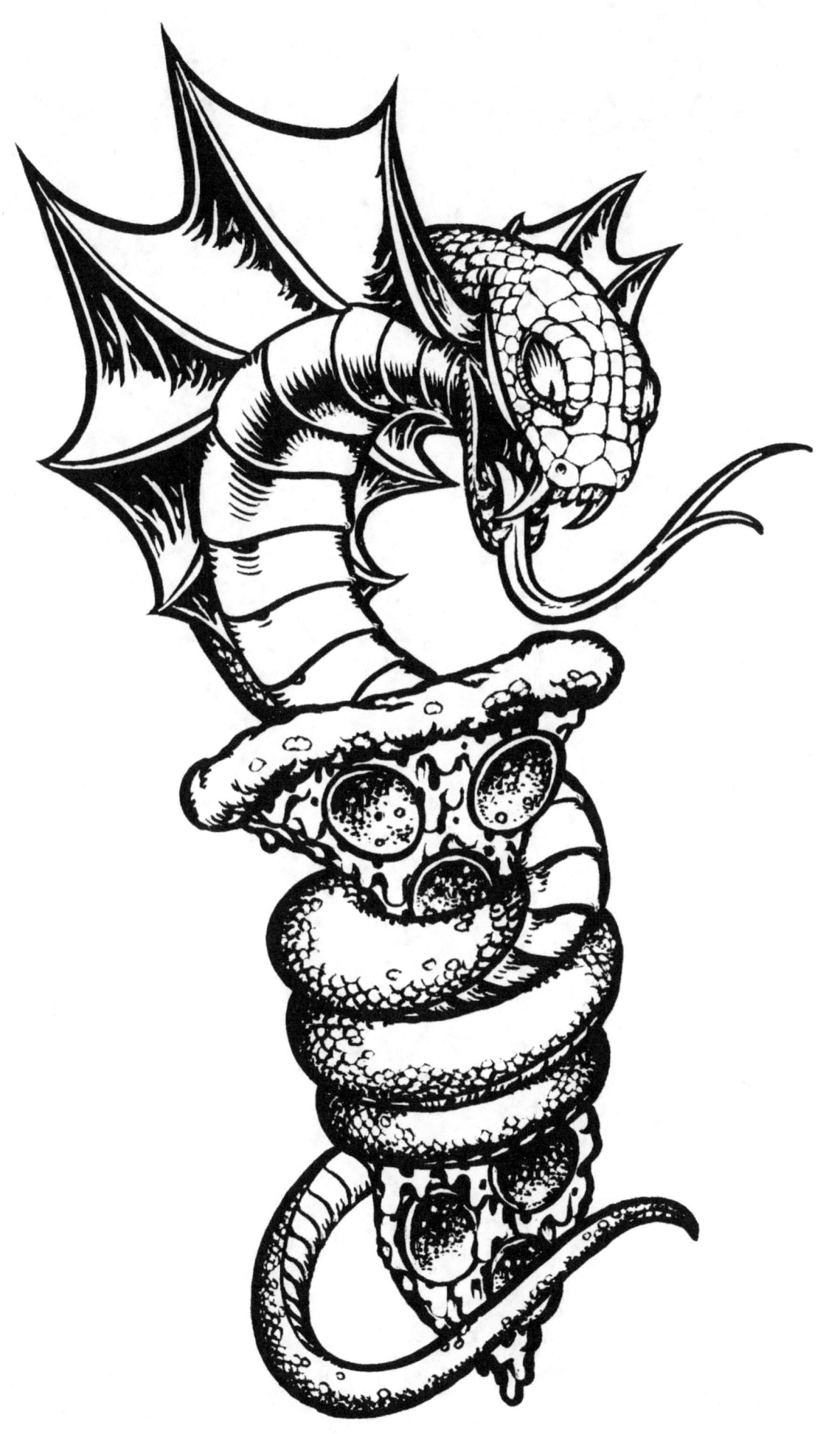

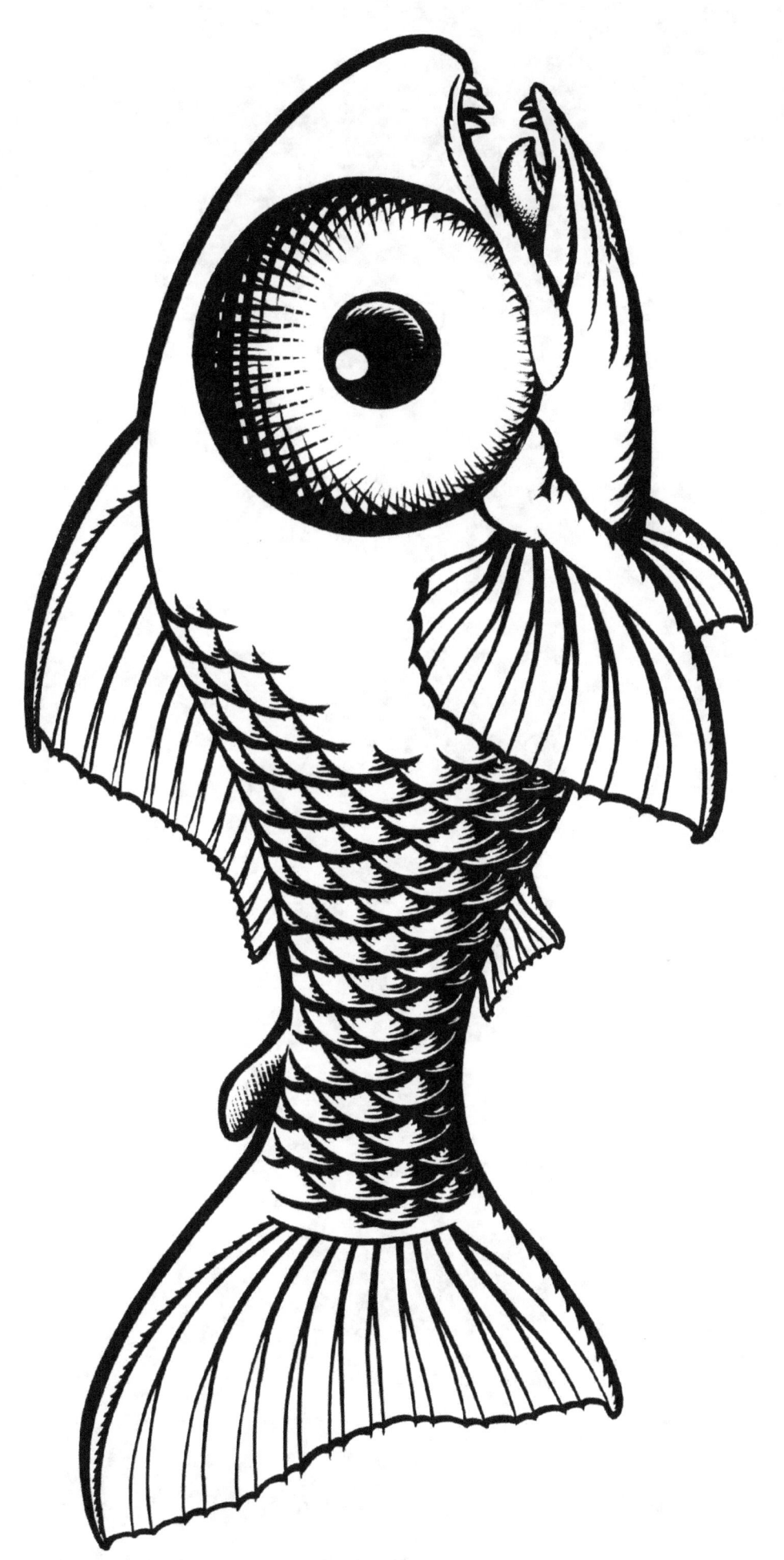

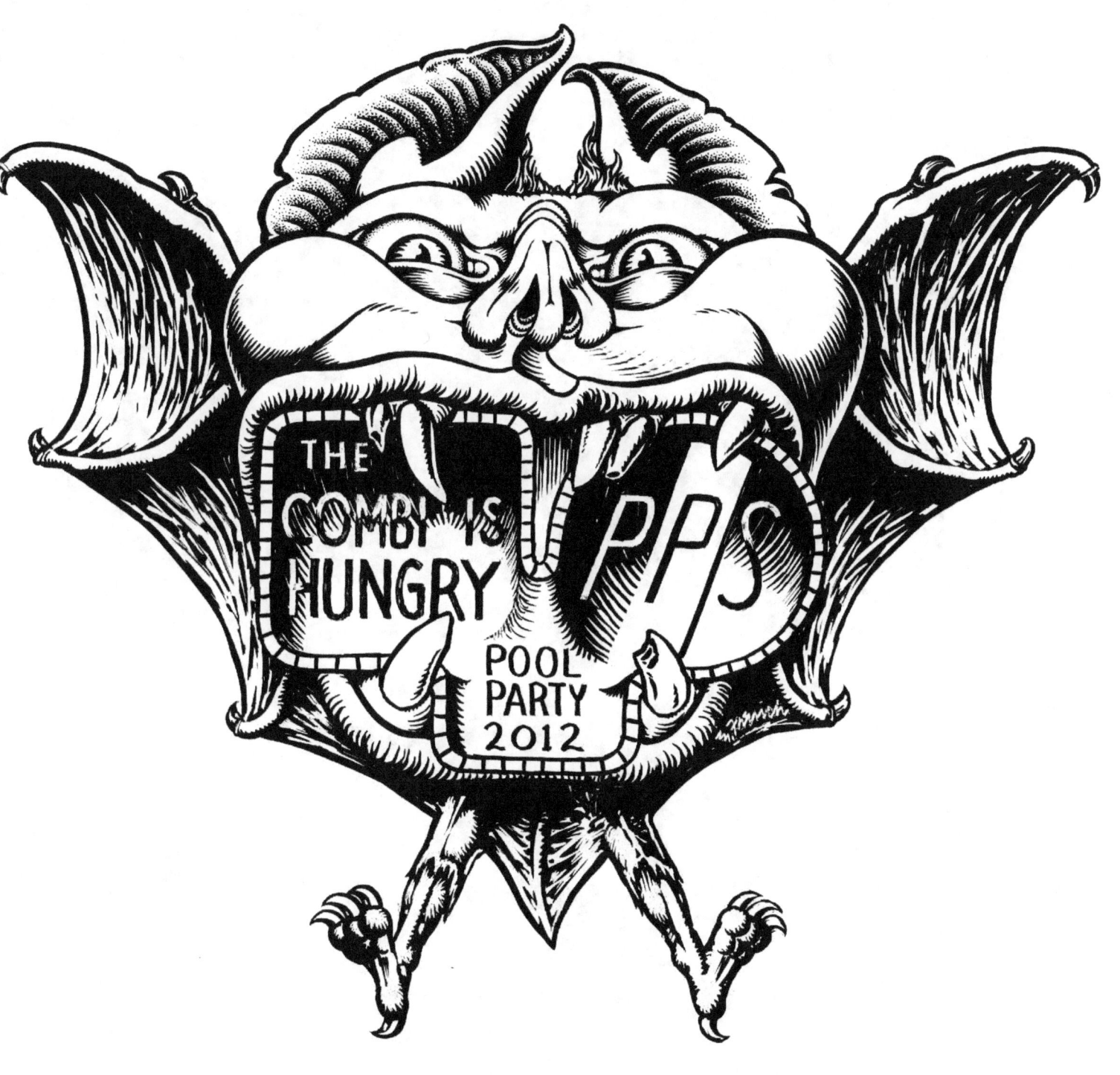

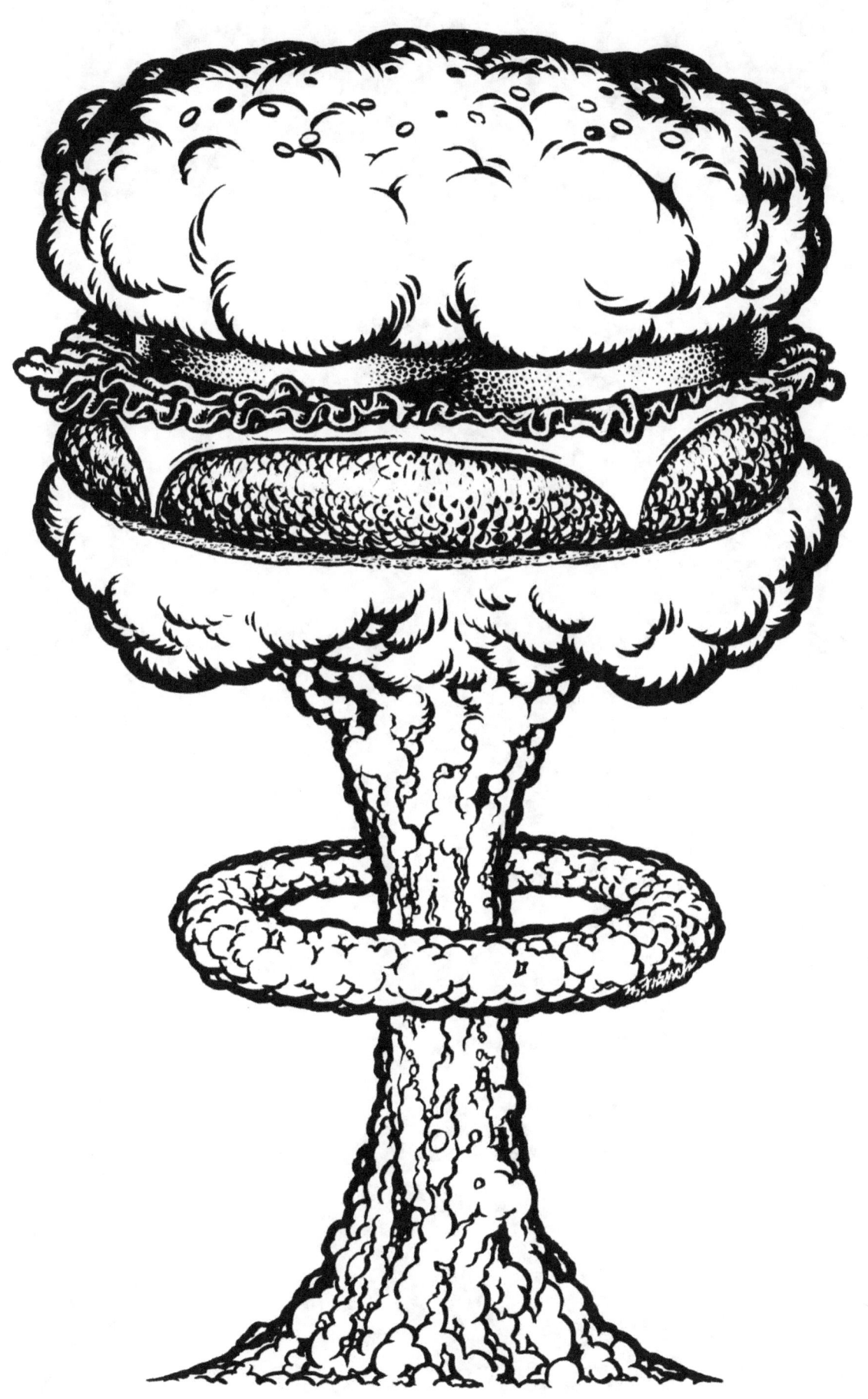

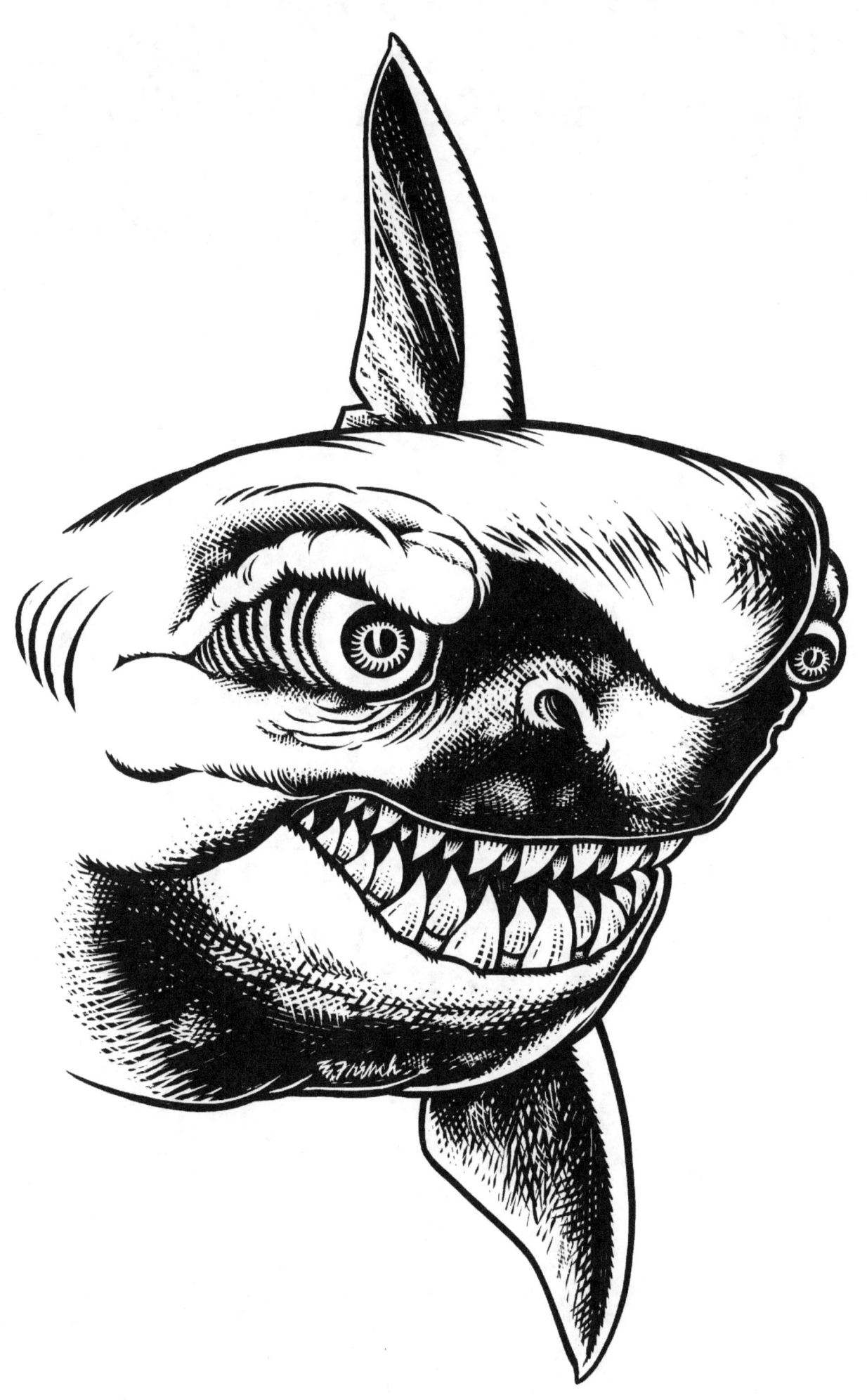

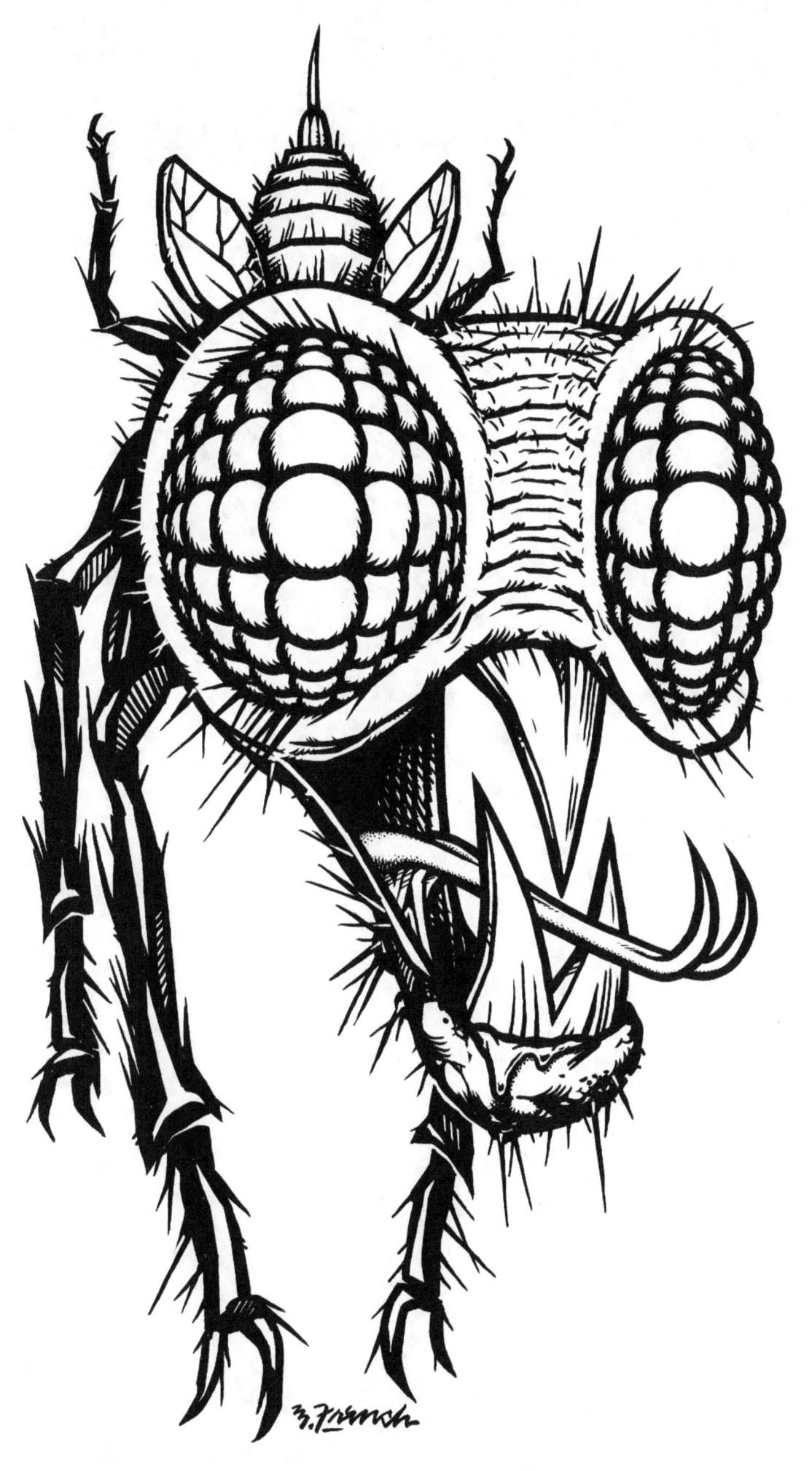

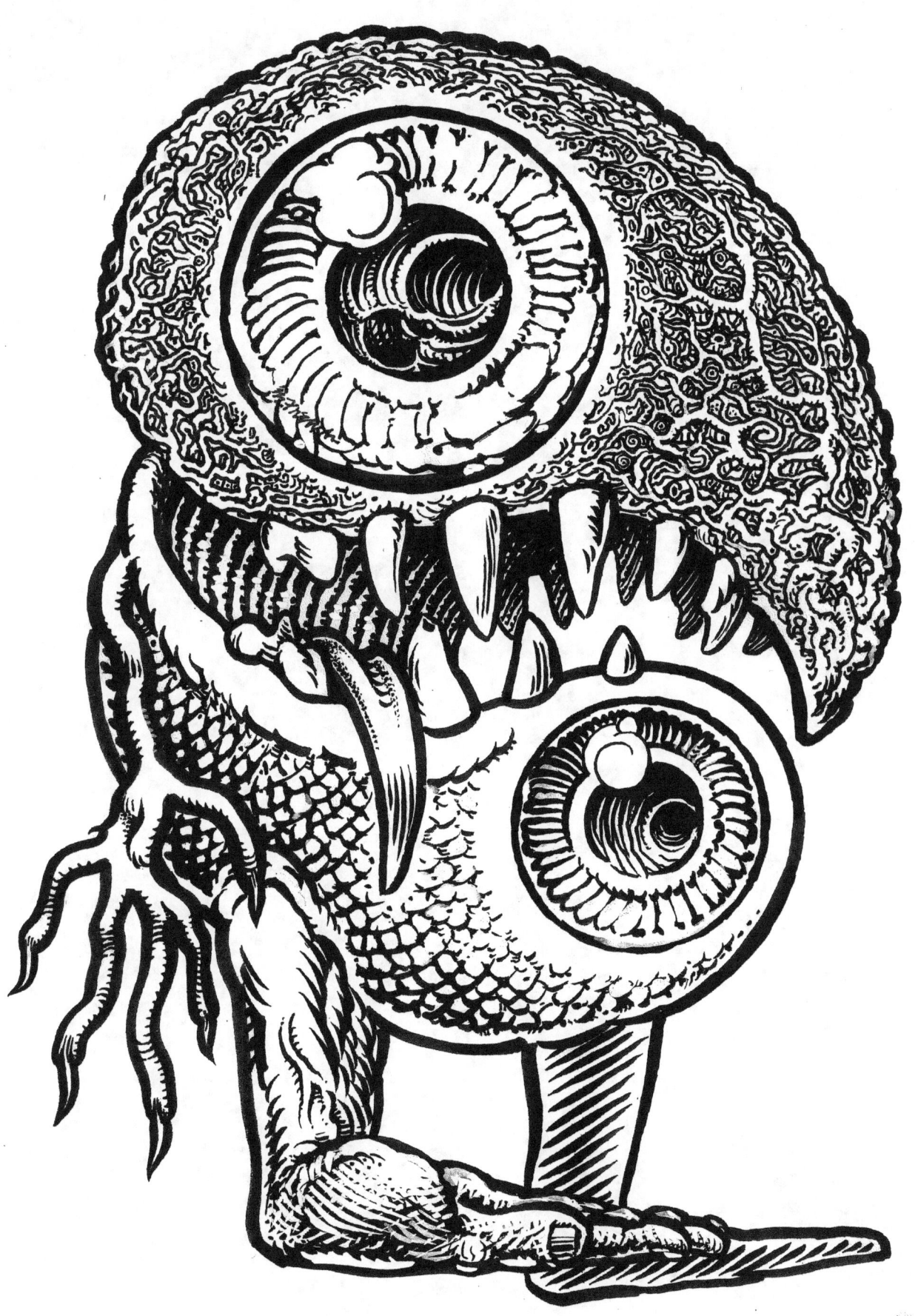

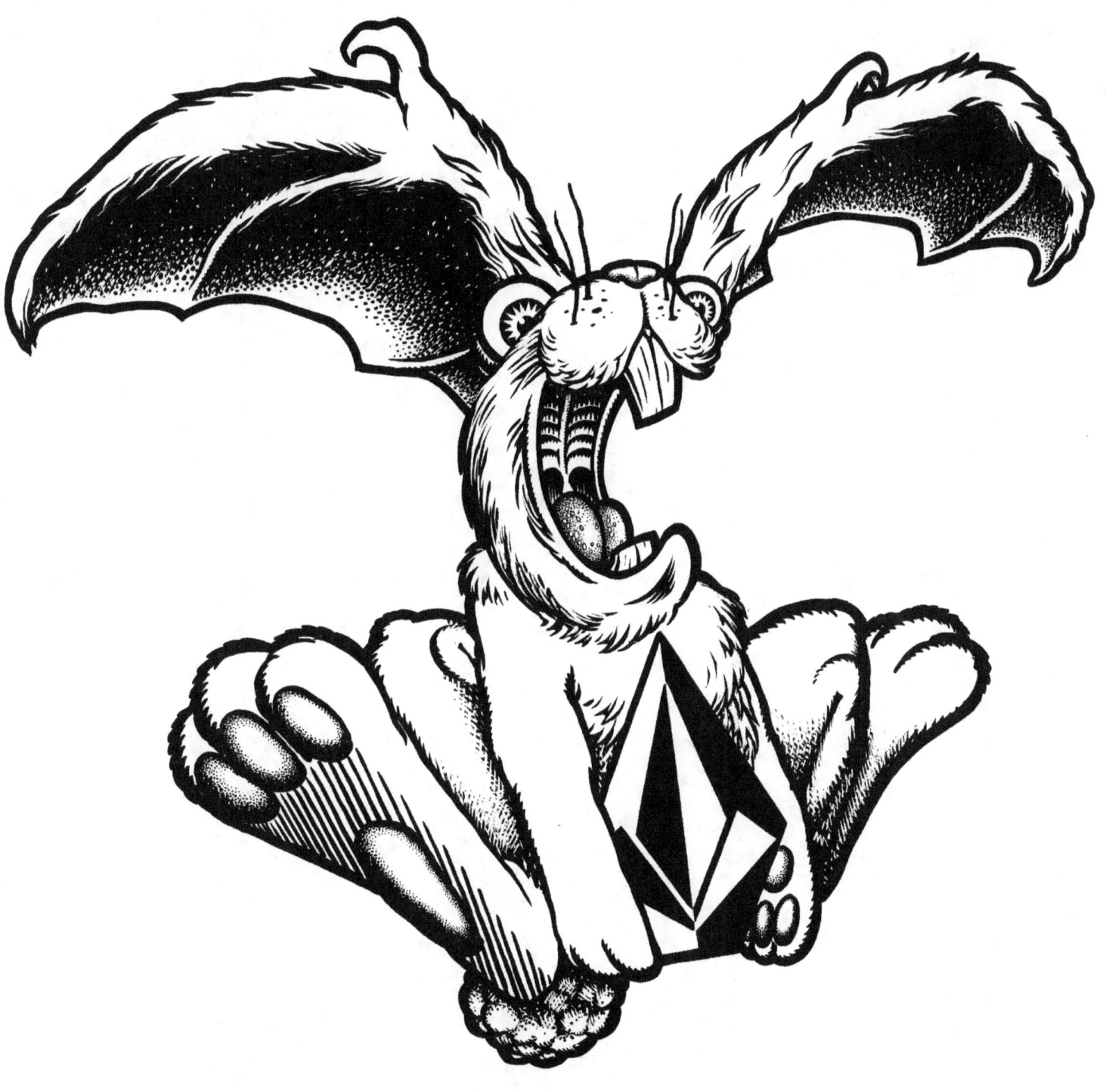

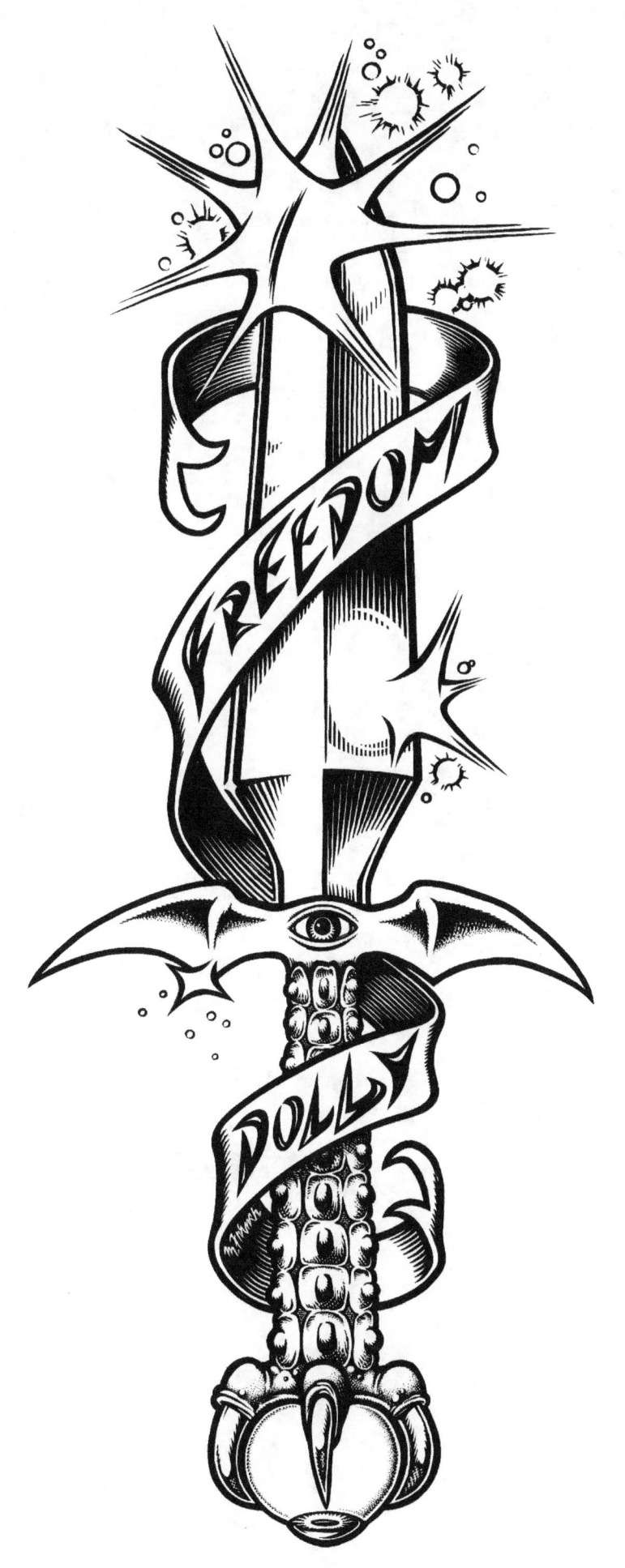

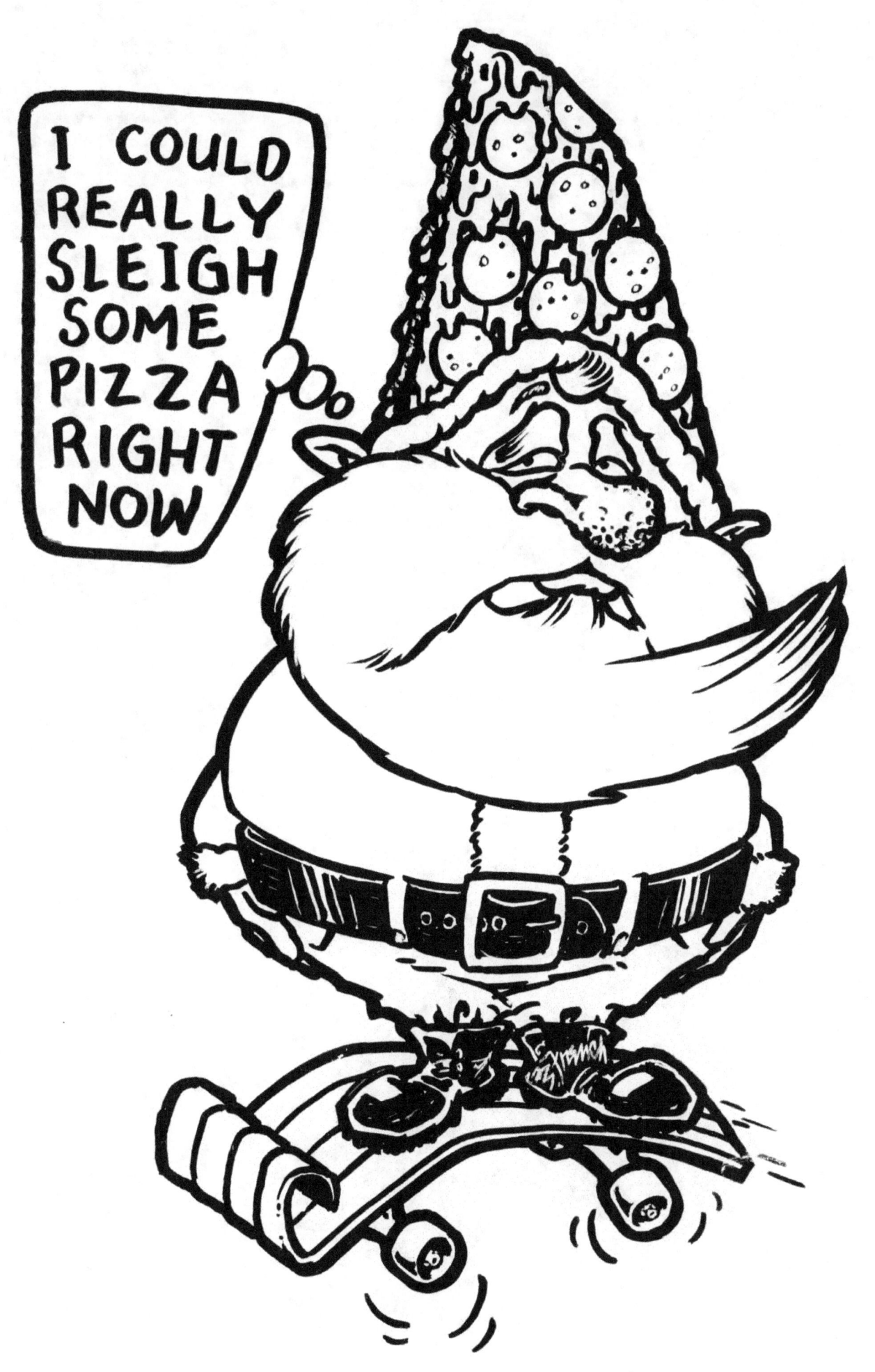

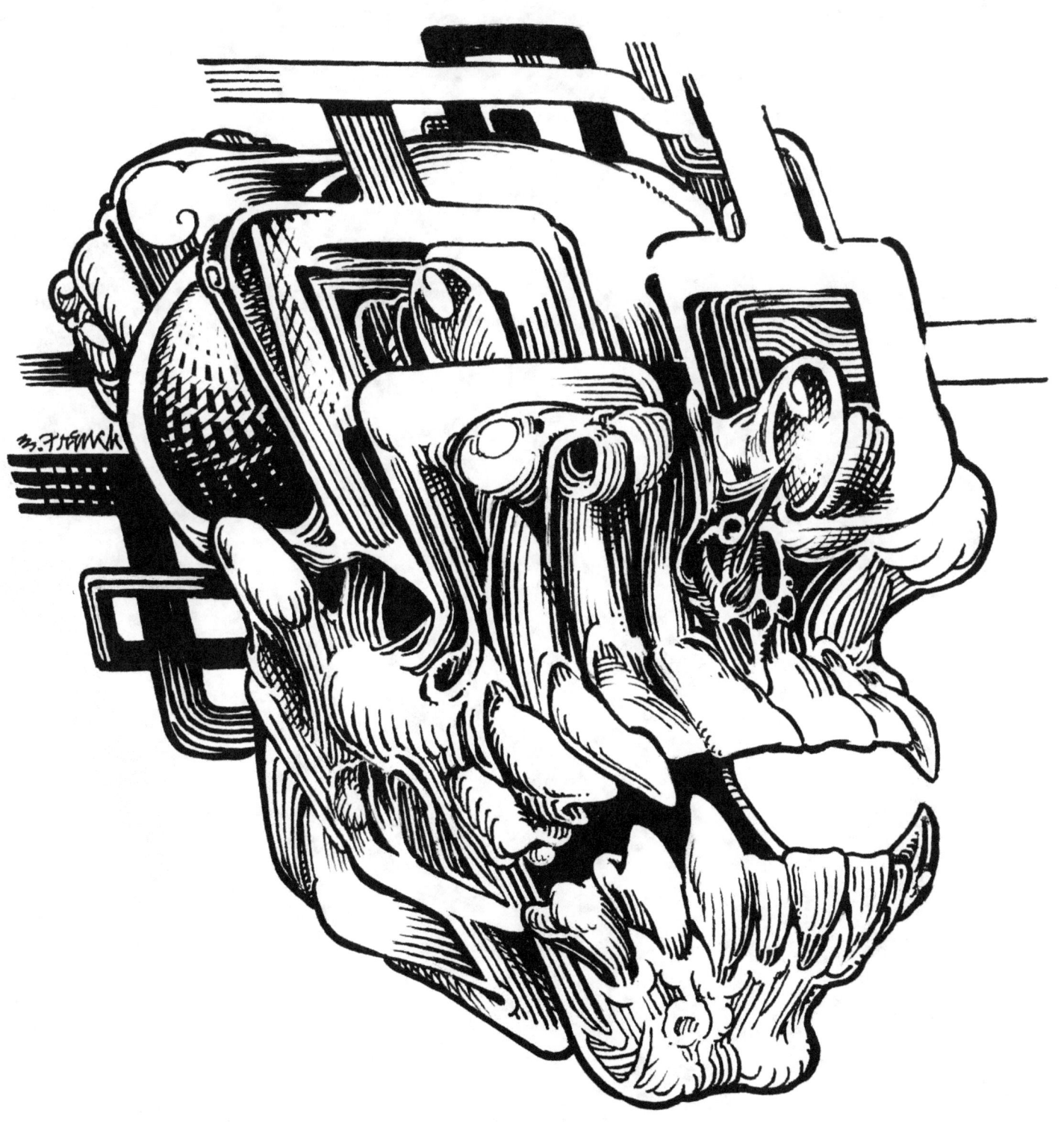

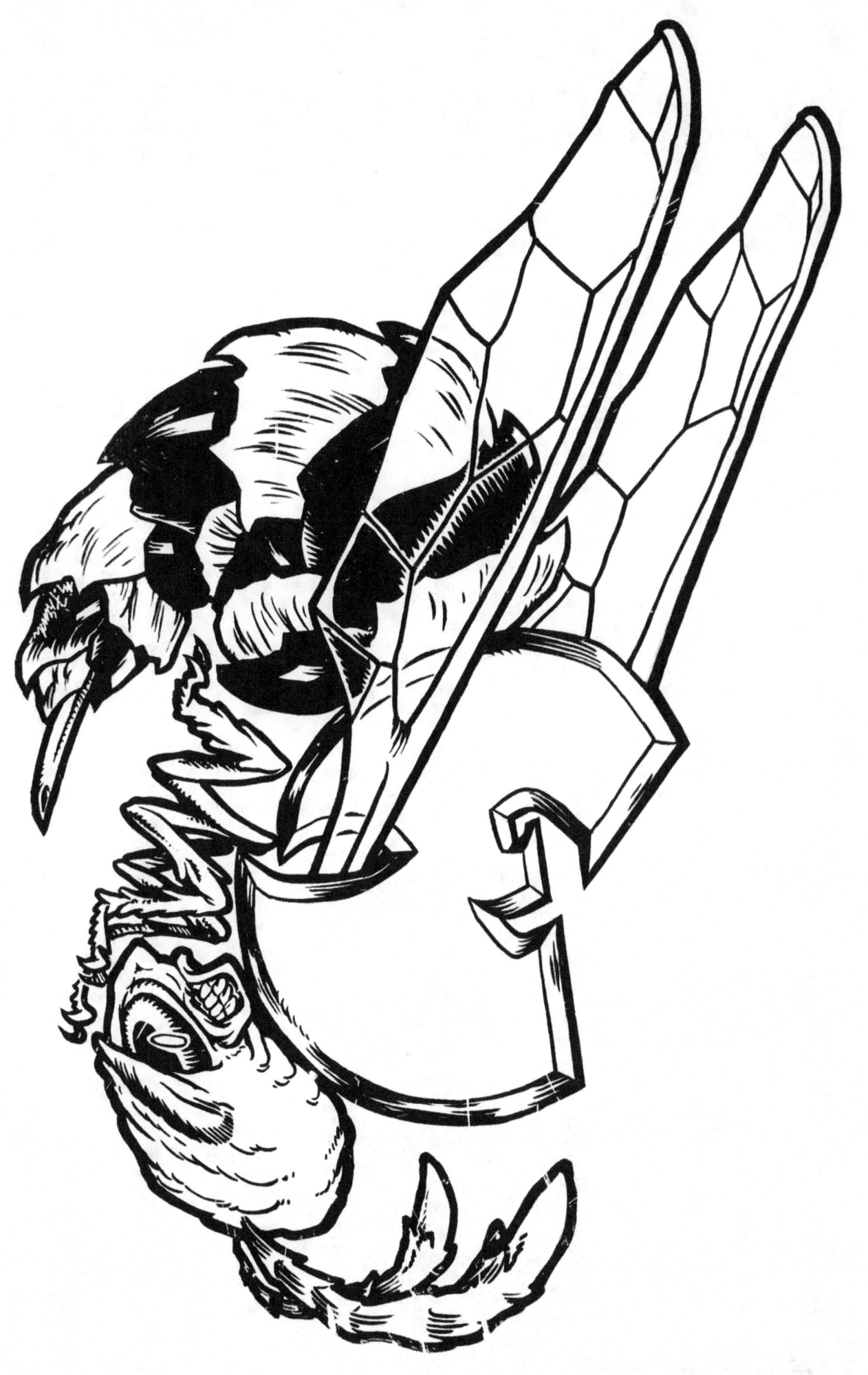

www.ingramcontent.com/pod-product-compliance
Lightning Source LLC
Chambersburg PA
CBHW081452220526
45466CB00008B/2614